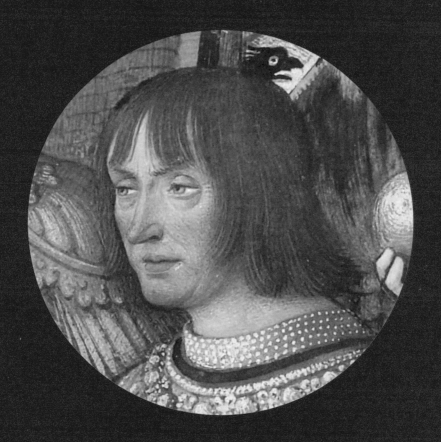

# THE MEDIEVAL IMAGINATION

# Faces

## OF POWER & PIETY

ERIK INGLIS

THE J. PAUL GETTY MUSEUM
THE BRITISH LIBRARY

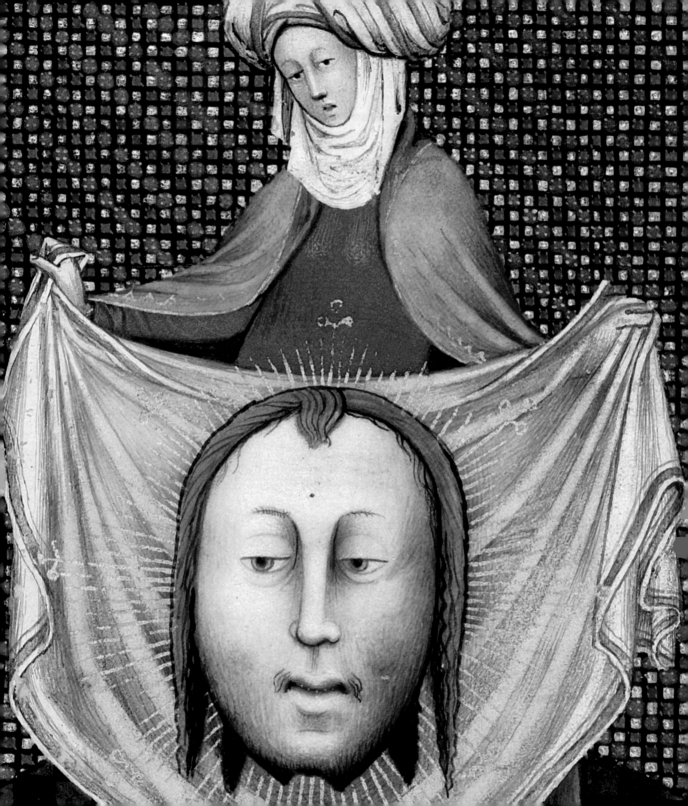

Published by the J. Paul Getty Museum, Los Angeles

Getty Publications
1200 Getty Center Drive, Suite 500
Los Angeles, California 90049-1682
www.getty.edu

Gregory M. Britton, *Publisher*
Mark Greenberg, *Editor in Chief*

Elizabeth Morrison, *Series Editor*
Mollie Holtman, *Editor*
Robin H. Ray, *Copy Editor*
Kurt Hauser, *Designer*
Amita Molloy, *Production Coordinator*

First published in Europe in 2008 by
The British Library
96 Euston Road
London NW1 2DB
www.bl.uk

Printed and bound in Singapore by Tien Wah Press

Library of Congress Cataloging-in-Publication Data
 Inglis, Erik.
 Faces of power & piety / Erik Inglis.
  p. cm. — (The Medieval imagination)
 ISBN 978-0-89236-930-0 (hardcover)
 1. Portraits, Medieval. 2. Illumination of books and
manuscripts, Medieval. I. J. Paul Getty Museum. II. British
Library. III. Title. IV. Title: Faces of power and piety.
 ND3337.I54 2008
 745.6'70940902—DC22
                    2008005636

British Library Cataloging-in-Publication Data
A catalogue record for this book is available from the British Library
ISBN 978-0-7123-0981-3

Front cover: Detail of *Initial G: Saint Blaise* (fig. 33), p. 37.

Back cover: Detail of *Christine de Pisan Presenting Her Book to the Queen of France* (fig. 53), p. 59.

Frontispiece: Detail of *Robert of Anjou, King of Naples, Sitting on His Throne* (fig. 18), p. 19.

## Sources for Quotations

Page 4: Quotation from Cyril Mango, *The Art of the Byzantine Empire, 312–1453*, reprint (Toronto, 1986), p. 17.

Page 10: The author's translation is from the passage cited in M. Seguy, "Hippocrate victime des images: à propos d'un épisode déconcertante de l'*Estoire del Saint Graal,*" *Romania* 119 (2001), p. 450.

Page 15: Jean de Meun, *The Romance of the Rose*, translated by Charles Dahlberg (Princeton, N.J., 1971), p. 274.

Page 23: Quotation from Michael Baxandall, *Painting and Experience in Fifteenth-Century Italy: A Primer in the Social History of Pictorial Style* (Oxford, 1972), p. 57.

Page 26: Quotation from Creighton Gilbert, "The Archbishop on the Painters of Florence, 1450," *Art Bulletin* 41, no. 1 (March 1959), p. 76.

Page 28: Quotation from Gerhard Wolf, "From Mandylion to Veronica," in G. Wolf and Herbert Kessler, eds., *The Holy Face and the Paradox of Representation* (Bologna, 1998), p. 170.

Page 43: Saint Augustine, *The City of God*, book 3, ch. 4, translation by Henry Bettenson (London, 1984), p. 92; and Francesco Petrarch, *Letters of Old Age* (*Rerum senilium libri*), translated by Aldo S. Bernardo, Saul Levin, and Reta A. Bernardo (Baltimore, 1992), vol. 1, Letter 1, 5, p. 21.

Page 77: The Florio and Filarete quotes on Fouquet as a portraitist are from Wolfgang Stechow, *Northern Renaissance Art, 1400–1600: Sources and Documents* (Englewood Cliffs, N.J., 1966), pp. 145–46.

Page 80: The author's translation is from Jacques LeGrand, *Archiloge Sophie: Livre de bonnes meurs*, Evencio Beltran, ed. (Paris, 1986), p. 395.

The copyright of the illustrations is indicated by the initials JPGM (J. Paul Getty Museum) and BL (British Library). Figures 30 and 70 are © The Hague, Koninklijke Bibliotheek, The Netherlands.

## Author's Acknowledgments

I am grateful to the following people for their help: Thomas Kren, senior curator of manuscripts at the J. Paul Getty Museum, for the invitation to write the book; Elizabeth Teviotdale for her work on the earlier exhibition from which it grew; Elizabeth Morrison, curator of manuscripts, for her help, encouragement, and above all the example of her own book, the first in this series; Jessica Berenbeim and Peter Kidd at the British Library, for their guidance through its collection; and Heather Galloway, for listening, reading, and everything else. I dedicate the book to Jonathan Alexander.

# CONTENTS

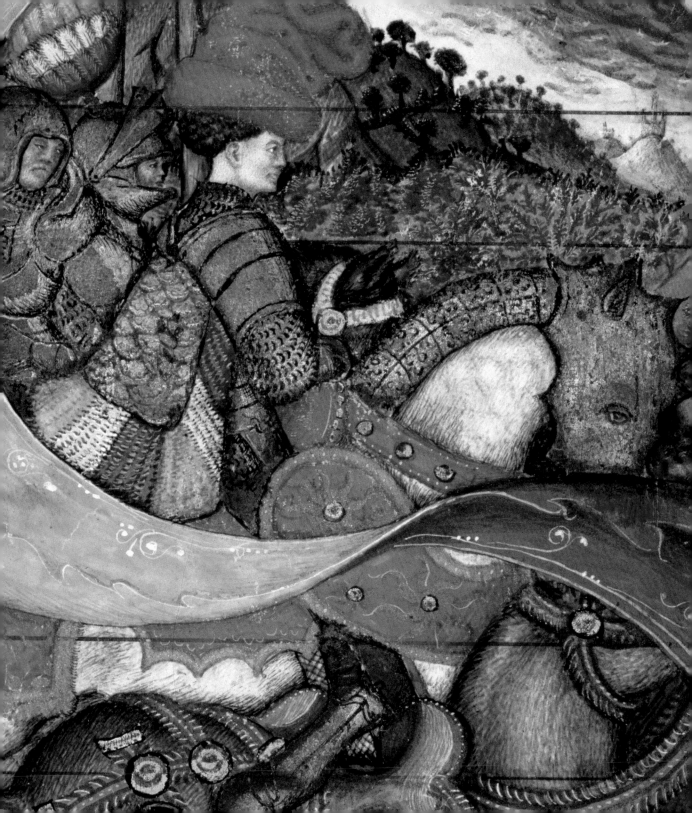

## FOREWORD

*Faces of Power and Piety* is the second in a new series of Getty Museum publications intended to reveal to the reader medieval conceptions of the world and their expression in art. The series, called the Medieval Imagination, is designed for a wide audience, and this volume, like its predecessor, is presented in collaboration with the British Library. *Faces of Power and Piety* plays an especially compelling role in the series as it opens up notions of portraiture that are little known to the modern viewer. Much of medieval portraiture is not about likeness, that is, an image that actually resembles the physical aspect of the sitter, but is more conceptual and abstract, rarely steeped in observation (or even the possibility of it). Thus, depictions of Christ, the evangelists, and other biblical figures, for example, were based on ideas loosely handed down from generation to generation. Portraits of individuals long since departed from this world, and whose appearances were never recorded, were especially common. The role of likeness—along with portraits of the living—became important only toward the end of the Middle Ages and into the Renaissance.

We are grateful to Erik Inglis, professor of art history at Oberlin College, for his lively and informative introduction to the topic, drawing upon the rich holdings of the Getty and the British Library to illustrate his ideas. Elizabeth Morrison, curator of manuscripts at the Getty Museum and series editor, worked closely with the author to make it accessible to a broad audience. We would like to thank Rebecca Vera-Martinez and Michael Smith for the superb photography of works from the Getty collection and Kristen Collins, Christine Sciacca, Nancy Turner, and Mary Flannery for their part in the process of photography. Kurt Hauser, the designer of many elegant publications for the Getty's Manuscripts Department, conceived the idea for the Medieval Imagination series. He has also designed this book, once again arranging the stunning images in an arresting and revealing manner. We are also grateful to Mark Greenberg, Mollie Holtman, Amita Molloy, Ann Lucke, Leslie Rollins, Deenie Yudell, Karen Schmidt, and Rob Flynn at Getty Publications and David Way, Kathleen Houghton, and Lara Speicher at the British Library for their contributions to the realization of this volume and to the Medieval Imagination series.

*Thomas Kren*
*Senior Curator of Manuscripts*
*The J. Paul Getty Museum*

*Scot McKendrick*
*Head of Western Manuscripts*
*The British Library*

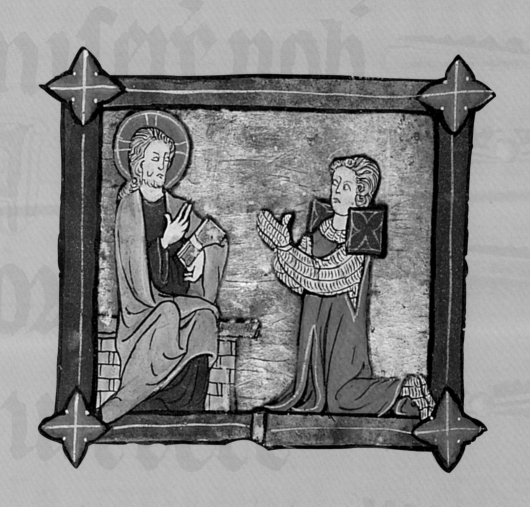

Think of your favorite picture of a close friend. Chances are this portrait captures your friend's personality by combining qualities of intimacy, spontaneity, and either humor or quiet reflection. The portrait succeeds by revealing something of your friend's character; the portrait probably also simply looks like your friend. These are the two demands that we modern viewers place on portraiture: first, a convincing likeness of the subject's appearance, and second, some expression of the subject's inner self.

Now, look at a portrait produced almost seven hundred years ago (fig. 1). This portrait appears in a manuscript that was used in private religious devotion; it shows the book's owner, clad in armor, kneeling in prayer before Christ (for other portraits in this manuscript, see fig. 32). The artist did not take pains to record the knight's features, nor does the image communicate much about the owner's personality. Compared to your favorite picture of a friend, this portrait may seem to lack a sense of realism and individuality. But medieval viewers like this knight valued the components of an individual's identity differently than we do. Because the occasion for this portrait was devotional, it presents the subject's formal, public face, conforming to contemporary expectations. Few people smile in medieval portraits, for example, since smiling would be considered frivolous in such contexts. Emphasizing the subject's power and piety, the image shows the knight not as he appeared at a single moment but as he wished to be remembered for the ages—not as he is, but as he should be. Medieval portraits thus almost invert our standards: while we expect portraits to imitate our appearance, medieval people hoped to imitate their portraits' example.

Medieval portraits sought to place their subjects in context, telling us more about office or status than about personality. For instance, this portrait (fig. 1) declares, "I am a knight." The props and trappings of high office; the magnificent garb and heraldry of nobility; the humble uniforms of the devout—artists of the Middle Ages carefully painted in the clues that would tell their contemporaries about the subject's place in society. A realistic likeness was far down on the list of priorities.

This book examines how portraits from the years 700 to 1600 fulfilled the expectations of their audiences. It begins with the break with classical Roman art that ushered in the age of medieval portraiture, and continues through the development of naturalistic portraits in the late Middle Ages and Renaissance. Then we look in detail at two subject types as they evolved over nearly a millennium: portraits of illustrious historical figures, and portraits of living people. The book concludes with a section on the moral dangers that portraiture was deemed to pose.

1 ◁
**A Man Kneeling before Christ**
Ruskin Hours
Northern France, ca. 1300
JPGM, Ms. Ludwig IX 3,
fol. 102v

1

# LIKENESS AND IDENTITY: THE EVOLUTION OF MEDIEVAL PORTRAITURE

## SYMBOLS OF RANK AND GLORY: THE EARLY MIDDLE AGES

Medieval portraiture had its roots in the late Roman Empire, and the portraiture of classical antiquity served as a constant reference point for later artists. Classical portraiture, like classical art generally, had as its touchstone the realistic representation of the visible world; thus, a portrait claimed to give its viewers an accurate likeness of its subject. Hence portraits from Roman Egypt present individualized likenesses that strike us as almost modern (fig. 2).

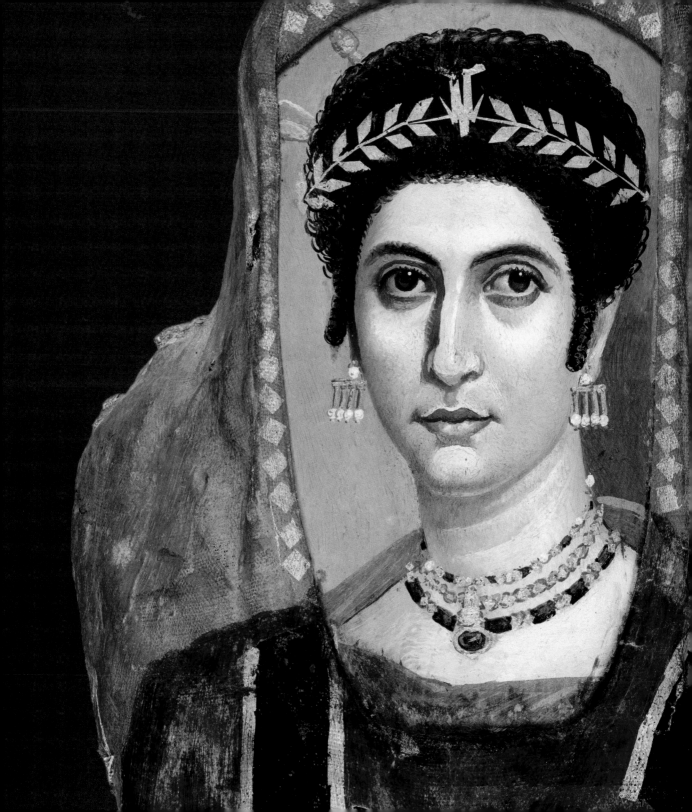

But already in the classical period these norms faced resistance. In third-century Rome, the philosopher Plotinus forbade his students from commissioning his portrait, believing that even an accurate likeness would fail to capture his true identity. (His students ignored him, sneaking an artist into his lectures to observe him secretly.) Similarly, in the fourth century, Constantia, the Roman emperor's sister, asked Bishop Eusebius for a portrait of Christ. This was a novel request at that time, and Eusebius dismissed it as impossible, believing that no image could capture Christ's divinity. Concerning Christ's Transfiguration—when Jesus was transformed upon a mountain, becoming radiant, and being called "Son" by God—Eusebius wrote, "Christ showed that nature which surpasses the human one—when His face shone like the sun and His garments like light. How can one paint an image of so wondrous and unattainable a form?" Here Eusebius adopts the traditional complaint, like Plotinus's, that realistic portraiture cannot do justice to an individual's identity, using it to say that no portraits can do justice to God.

**2** (overleaf)
**Mummy Portrait of a Woman**
Attributed to the Isidora Master
Fayum, Egypt, ca. 100–110
Encaustic on wood; gilt, linen
JPGM, 81.AP.42

**3** △
**The Transfiguration of Christ**
Floreffe Bible
Meuse Valley, ca. 1155
BL, Add. Ms. 17738, fol. 4

Eusebius was voicing a major dilemma that he and his contemporaries faced. The realistic art of fourth-century Rome was ill-suited to depicting anything like Christ's glorious nature. Their solution was to abandon the naturalism of Greco-Roman art, instead developing sacred images that concentrated on timeless essentials. For example, in a depiction of the Transfiguration from a twelfth-century Bible, we see Christ's earthly body in a supernatural setting—hovering above the ground, haloed and radiant "like the sun" (fig. 3).

This stylistic shift had a dramatic effect on portraiture, as we can see in the opening image of the Eadui Psalter (fig. 4). It shows a group of monks offering the psalter to Benedict, the sixth-century founder of Benedictine monasticism. The book is named for its scribe, Eadui Basan, a monk of Christ Church Canterbury, who is shown embracing the feet of Benedict, enthroned beneath an arch; a tightly massed group of monks stands to the right. The contrasting depictions of Benedict and the monks offer an excellent example of medieval portraiture. Though Benedict was long dead and there was no record of his appearance, the artist depicted him with the richest detail; the living individuals who actually read the book—the

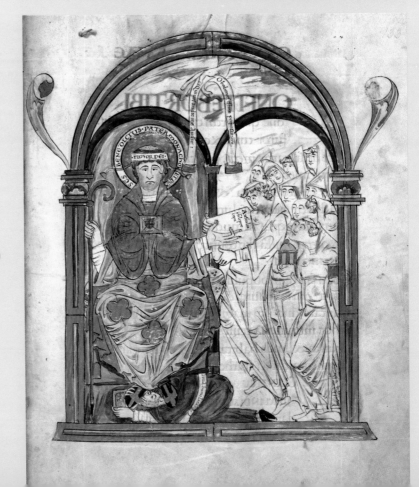

**4 ▷**
**Eadui Basan and the**
**Monks of Canterbury**
Eadui Psalter
Southeast England, between
1012 and 1023
BL, Arundel Ms. 155, fol. 133

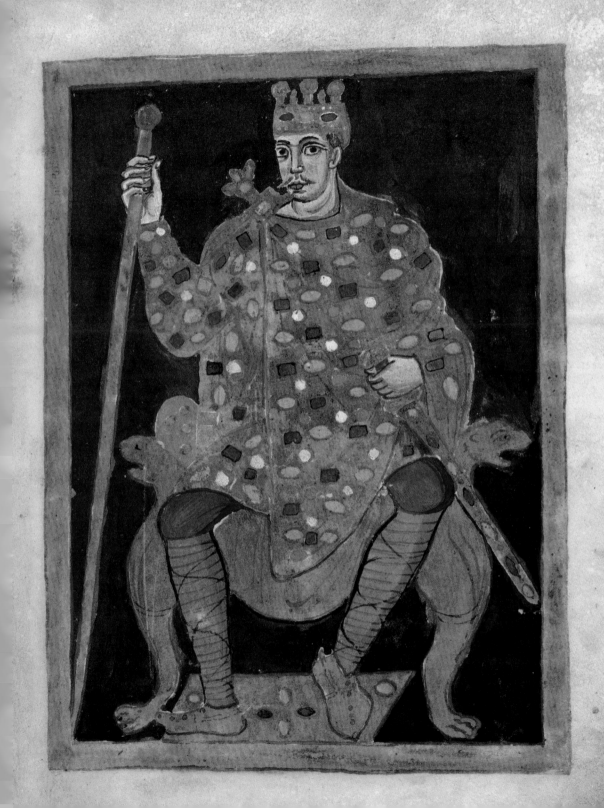

**Portrait of Emperor Lothaire**
Lothaire Psalter
Carolingian Empire, ca. 800s
BL, Add. Ms. 37768, fol. 4

Lothaire was the grandson of
Charlemagne, founder of the
Carolingian dynasty that produced
the first series of ruler portraits
in medieval Europe. Self-declared
heirs to the ancient Roman rulers,
Carolingians based their portraits
on classical models. Here, for
example, Lothaire sits on a *sella
curulis*, an ancient Roman throne,
while the book's cover features
a bust of Lothaire modeled on
ancient coins (fig. 6). The miniature
gives Lothaire a monumental pres-
ence: crowned and gazing directly
at the viewer, he fills the frame,
wearing a gem-studded robe that
looks like the product of a medieval
version of the rhinestone-fastening
BeDazzler.

**6** ▷

**Bust of Lothaire**
Lothaire Psalter
Carolingian Empire, ca. 800s
BL, Add. Ms. 37768, cover

monks of Christ Church—are rendered generically and, with the exception of Eadui,
with lines alone. Though seated, Benedict is larger than the standing monks beside
him, and he addresses the viewer with a motionless, fixed symmetry that contrasts
with the livelier three-quarter poses of the monks. Using every detail to make Bene-
dict more substantial and imposing than the monks, the portrait indicates that his
timeless sanctity outshines the mortals before him. But the image also admits that
some things escape portraiture's grasp; descending from the clouds we see only the
hand of the unportrayable God.

Modern viewers, who are used to realistic, individualized portraits, may be
forgiven for feeling that such medieval paintings do not constitute "true" portraits.
From the medieval point of view, however, these portraits are every bit as concerned
with recognizability and character as modern examples; viewers simply understood
these terms very differently. Contemporary portraits start with a realistic likeness
and hope for something of the person's identity, while medieval portraits started
with the person's identity and left out distracting and unnecessary elements such
as physical appearance. Identification was assured in other ways, for a portrait can
be recognizable without being realistic. Many subjects are identfiable by their attri-
butes—objects associated with them. Attire is the most important: armor indicates
a knight, a hooded robe a monk, a fine gown a noble lady. Attributes could also be
more specific: Saint Peter holds the keys to heaven, Saint Paul carries a sword, an
aristocrat appears with his family's coat-of-arms. By carefully using distinguishing
features such as age, social rank, and gender in an image, artists could attain a sur-
prising specificity that may have allowed their patrons to identify themselves in a
portrait. Finally, artists could inscribe a name near the por-
trait, ensuring the correct identification.

Take the image of Engilmar, bishop of Parenzo,
which opens the benedictional he had made around
1030 (fig. 7). Comparing it to the Fayum portrait
(fig. 2), we are hard-pressed to believe that the few
lines indicating his face can tell us what Engilmar
looked like. But his face grows in specificity when it
is compared with the others in the image. Engilmar
alone has gray hair; his tonsure (the shaved crown of
the head, indicating monastic vows) distinguishes him
from the church-goers at the left, while his beard sets him apart from the youth-
ful, clean-shaven churchmen who flank him at the altar. Finally, the picture shows
Engilmar celebrating mass, mirroring his use of the benedictional, a book of liturgi-
cal blessings read by a bishop. These elements combine to make Engilmar the only
unique figure on the page. Because a medieval viewer needed few cues to make a
picture meaningful, these distinctive elements may have sufficed for Engilmar to
recognize himself. Still, the artist took no chances and inscribed the image with
Engilmar's name.

7 ▷
**Bishop Engilmar**
**Celebrating Mass**
Benedictional
Regensburg, ca. 1030–40
JPGM, Ms. Ludwig VII 1,
fol. 16

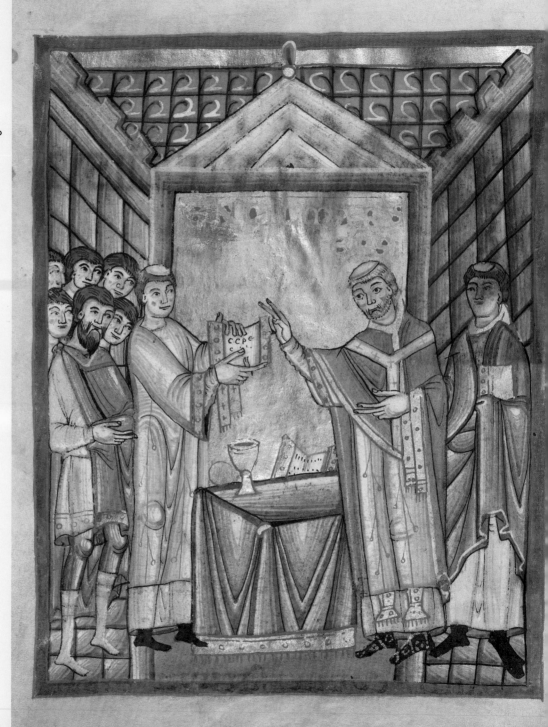

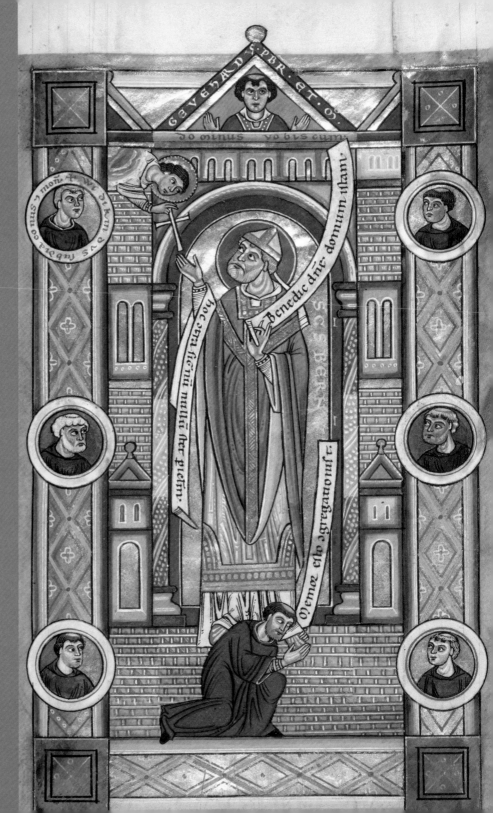

**8** ▷

**Saint Bernward of Hildesheim**
Stammheim Missal
Hildesheim, ca. 1170s
JPGM, Ms. 64, fol. 156

An angel offers a relic of Christ's cross to Bernward, abbot of Saint Michael's monastery in Hildesheim, Germany, and a celebrated patron of art. After his death in 1022, Bernward was revered at his monastery; this manuscript, produced at the abbey a century later, was dedicated to him and invokes his blessing on its monks, several of whom appear in the picture. Heinricus, possibly the book's painter, kneels prominently at the abbot's feet. The remaining seven monks may also have contributed to the book, but only two are named, Geverhardus and Widikindus.

The artist endows the long-dead Bernward and the living monks with similar facial features: firmly drawn cheeks, straight noses, and prominent eyes. The variations in the monks' appearance—two are blond, two have brown hair, and two are gray and bearded—are more likely intended to evoke a representative selection of monks than to convey any particular person's looks.

## THE INDIVIDUAL PORTRAYED:
## THE LATER MIDDLE AGES AND RENAISSANCE

The years between 1150 and 1250 saw dramatic changes in the history of art. Artistic production and patronage became primarily a secular business, shifting from the cloister to the court and the city. Artists also became increasingly interested in depicting the visible world with a new realism. Thus Matthew Paris, a chronicler and artist active at the monastery of Saint Albans, England, between 1235 and 1259, recorded the French king's gift of an elephant to the king of England in a closely observed portrait of the animal (fig. 9).

Contemporary texts reveal a similar interest in realism. *The History of the Holy Grail*, written before 1235, describes a votive statue made "with the closest resemblance to the form of [its subject] as possible." And the early fourteenth-century poet Ottokar von Horneck described an artist who added wrinkles to Rudolf of Habsburg's portrait as he aged. Though probably fictional, the story is revealing: Rudolf's face in his portrait, still displayed in Speyer Cathedral in Germany, is exceptionally wrinkled, and Ottokar's attempt to explain its unusual appearance reveals a new-found sense of naturalism.

Strikingly, these verbal accounts of realistic portraiture pre-date by decades the earliest surviving portraits that art historians accept as realistic. While Matthew Paris

**9** ▽
**Henry III's Elephant**
Matthew Paris
Matthew Paris, *Book of Additions*
Saint Albans, ca. 1250–54
BL, Cotton Nero Ms. D.I, fol. 169v

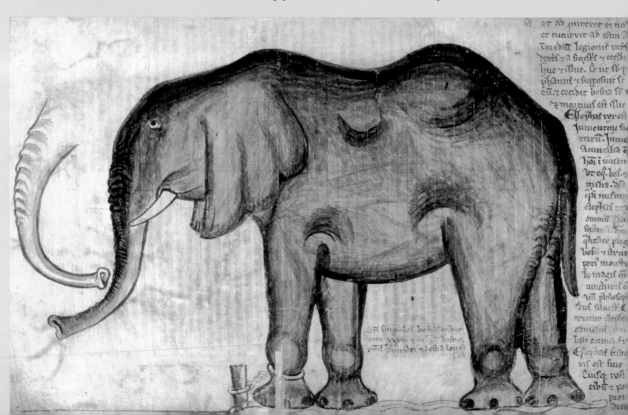

**Matthew Paris before the Virgin**
Matthew Paris
Matthew Paris, *History of the English*
Saint Albans, ca. 1250–59
BL, Royal Ms. 14 C.VII, fol. 6

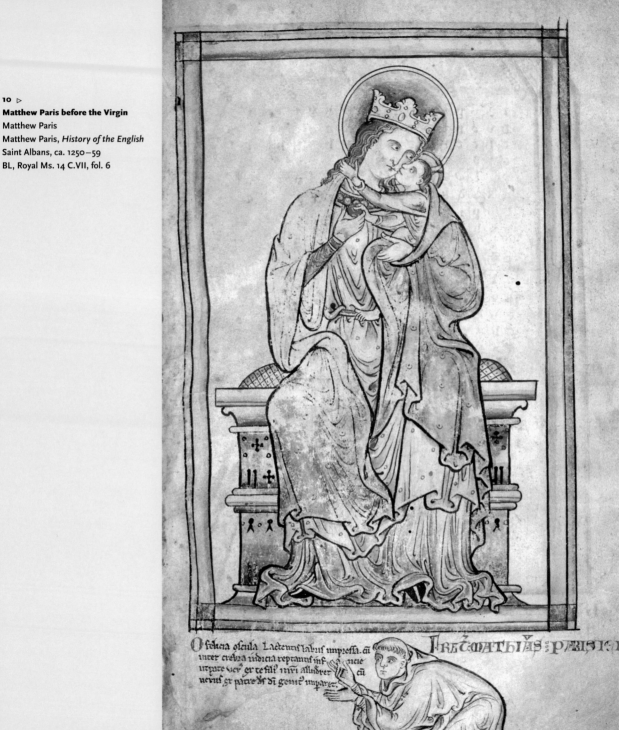

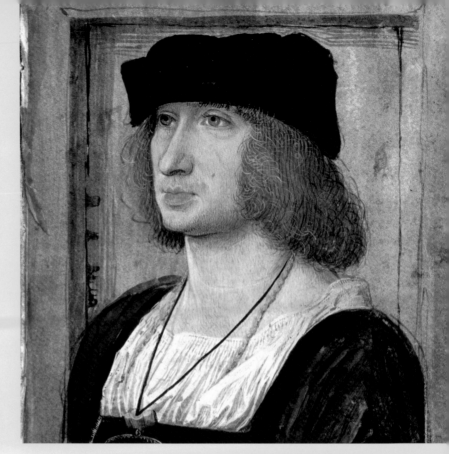

11 ▷

**Portrait of Pierre Sala**
Jean Perréal
Pierre Sala, *Love Poems*
Paris and Lyons, ca. 1500
BL, Stowe Ms. 955, fol. 17

studied the king's elephant closely, he apparently did not look in the mirror when producing his self-portrait before the Virgin, an image every bit as conventional as Eadui Basan's self-portrait from two centuries earlier (compare figs. 4 and 10).

It is not until the fourteenth century that we begin to see portrait likenesses as carefully studied as Paris's elephant (fig. 9). In this period we can compare multiple likenesses of the same person, and we can see that a new definition of recognizability was taking shape in portraiture all across Europe. The increasing realism carved out new roles for portraits: they were now used as documents to arrange marriages and as keepsakes of absent friends. For example, Jean Perréal's portrait of Pierre Sala, painted around 1500, appears in a collection of love poetry that Sala presented to Marguerite Bullioud, the object of his affection and his future wife (fig. 11). Sala commissioned the piece so that Marguerite could gaze on his features at all times; the book even came in a carrying case that she could attach to her dress. Sala's portrait has a convincing solidity that dominates the space of its illusionistic frame; his finely detailed face is modeled with delicate touches and gentle stippling indicates the subtlest shadow of a beard. Sala's impulse—to give a true likeness of himself to a loved one—feels very familiar to us. The image, though, remains somewhat formal and distant; despite its intimate purpose, it is still governed by the conventions of its time.

**Hedwig of Silesia with Duke
Ludwig and Duchess Agnes**
*Life of the Blessed Hedwig*
Silesia, 1353
JPGM, Ms. Ludwig XI 7, fol. 12v

*The Life of the Blessed Hedwig* opens
with an imposing depiction of the saint
(1174–1243), framed by architecture
and flanked by the book's patrons, Duke
Ludwig I of Liegnitz and Brieg and
his wife Agnes. This artist uses both
realistic and conventional elements to
distinguish the saint from the mortal
aristocrats who were her descendants.
Thus he uses strong modeling to give
Hedwig's face a persuasive volume.
Though Hedwig had been dead for
more than a century when this work
was painted, the imaginary portrait's
monumentality contrasts with the less
substantial portraits of the living Lud-
wig and Agnes, who in turn are more
detailed than the statuette of the Virgin
and Child that Hedwig holds in her
right hand. The use of different modes
for people of different status reveals a
strong continuity with earlier medieval
portraits like those in the Eadui Psalter
(fig. 4); this ability to balance innova-
tion and tradition is a hallmark of much
medieval art.

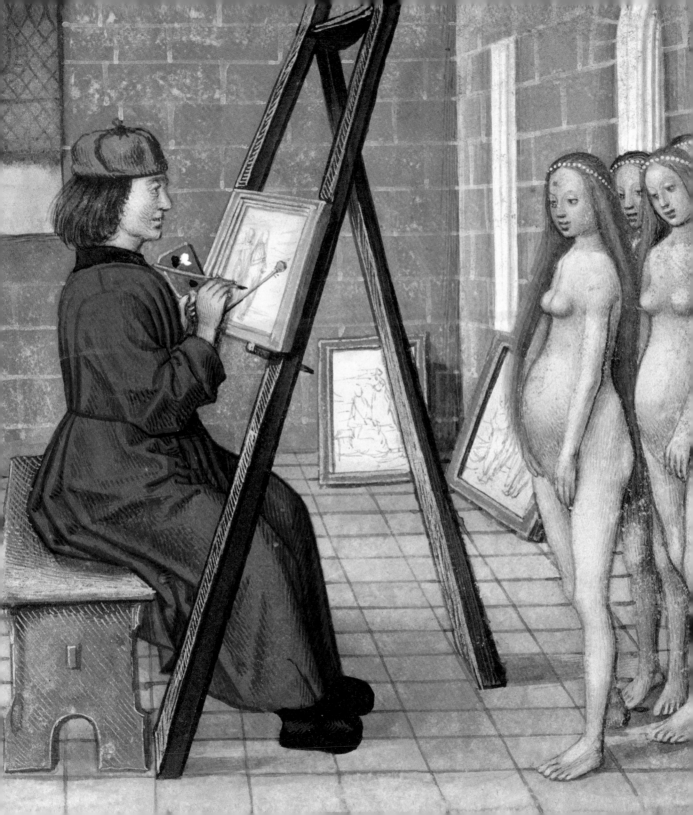

The development of observational portraiture introduced a new subject in European art: artists painting portraits from a live model, a subject that first appears in the fifteenth century. For example, the ancient painter Zeuxis, celebrated for the astonishing realism of his paintings, enjoyed a revival as realistic art came back into style. According to legend, when he was commissioned to portray Helen of Troy, considered the most beautiful woman in history, he gathered five stunning women in order to select the best features of each. While Zeuxis sounds like an exemplary realist, his story demonstrates the ambiguity of terms such as realism, convention, and invention. Zeuxis based his painting on close observations of his models, but fused these realistic details together to invent a portrait of a woman he had never seen. Jean de Meun gave the story a novel twist in his poetic masterpiece, the *Romance of the Rose*, saying that Zeuxis, despite his talent, was still not Nature's equal, "no matter how well he could represent or color his likeness [of Helen]." Given this ambiguity, it is not surprising that this depiction of Zeuxis (fig. 13), from a manuscript of the *Romance*, seems to miss the point, assigning identical features to Zeuxis's five different models.

This apparent confusion may surprise us, because we make a clear distinction between realistic and conventional portraits, and we may be perplexed that medieval artists and viewers did not embrace realistic portraiture without a backward glance

**13** ◁
**Zeuxis Painting**
Master of the Prayerbooks of
circa 1500
Guillaume de Lorris and Jean de
Meun, *Romance of the Rose*
Bruges, ca. 1490–1500
BL, Harley Ms. 4425, fol. 142

**14** ◁
**A Wise Man and a Fool, Each
Painting a Likeness of the Other**
Lyons Master
Pierre Sala, *Love Poems*
Paris and Lyon, ca. 1500
BL, Stowe Ms. 955, fol. 9*

The act of portrait painting was sometimes employed allegorically, as in this illustration of a poem on the theme of the world turned upside down. The times are such, the poem reads, that the "wise man counterfeits the fool, and the fool counterfeits the wise." While "counterfeit" today implies an unethical deceit, in the late Middle Ages it applied to any imitation, including portraiture. In this playful image, the fool and the sage counterfeit each other not in behavior, but in paint.

· 892 ·

Grave Rudolff, ain Sohn des grave Dametho, Ist auch ein Kriegsman, vnd vnnder
Khaÿser Hainrich deß ersten, Anno Neünhundert Zwaintzig, in hohem ansehen
gewest, Darumb er auch mit Herdzog Berchtolden in Baÿern, mit ainem ansehen=
lichen hauffen vom Adel, In die Anhundert Fünfftzig Pferdt starckh, vnd sehr
wol gerüst, dem Khaÿser Hainrichen zu Guet Ins Veldt, Wider die Vnger oder
hünen gezogen, So findt man Ine auch im Herdzog hannß von Zwaÿbrück=
en, oder Zimmern Pfaltzgrave Turnier Buech, ec, im Ersten Turnier zu Mai=
denburg gehalten, Welcher auch in sollichem Turnier, mit Herdzog hörman,
in Schwaben, auffgezogen, Hat neben dem Otto, ein Tochter gehabt, Margret
genambt,

**15** △
**Charles I Hohenzollern**
Probably Jörg Ziegler
*Chronicle of the Hohenzollern Family*
Augsburg or Rottenburg, ca. 1572
JPGM, Ms. Ludwig XIII 11, fol. 27

**16** ◁
**Rudolf Hohenzollern**
Probably Jörg Ziegler
*Chronicle of the Hohenzollern Family*
Augsburg or Rottenburg, ca. 1572
JPGM, Ms. Ludwig XIII 11, fol. 9

of regret. Consider the artist who illustrated the chronicle of the counts of Hohenzollern, which traces the family's genealogy. No one knew what the family's ancient ancestors looked like, so the artist was free to invent their portraits, giving Rudolf, a ninth-century count, a commanding, muscular presence (fig. 16). When it came time to paint Count Charles I of Hohenzollern, the family's living patriarch, however, the artist chose to err on the side of reality, and the contrast between the heroic, invented past and the lumpen, realistic present is quite striking (fig. 15).

Michelangelo, the quintessential Renaissance artist and a great student of human anatomy, faced a similar dilemma when sculpting a portrait of Giuliano de Medici for the Medici tombs in Florence. A contemporary griped that the real Giuliano looked nothing like his portrait, an observation few would have made during the Middle Ages. Michelangelo countered that although the portrait did not conform to Giuliano's appearance, it would become his lasting likeness and ensure his posthumous fame. The artist was right.

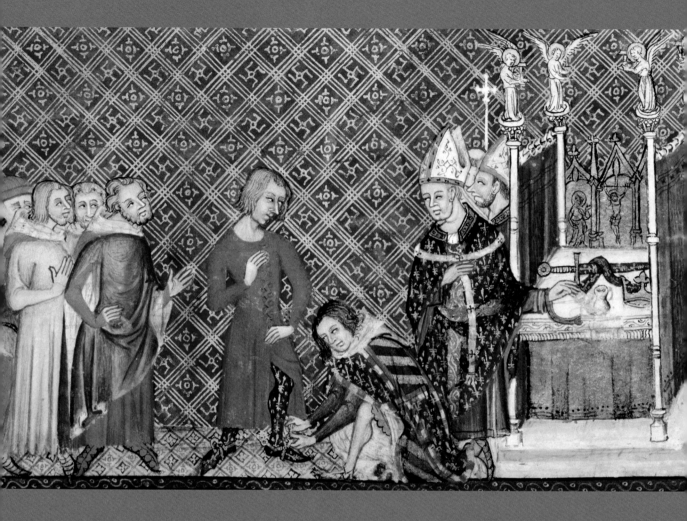

**17** △
**King Charles V Receives Spurs
from Philip the Bold**
Master of the Coronation Book
*Coronation Book of Charles V
of France*
Paris, 1365
BL, Cotton Tiberius Ms. B.VIII,
fol. 48v

Charles V (reigned 1364–80) is the first French king for whom we have numerous recognizable portraits produced by different artists in different materials. These depict him as a middle-aged man with a distinctly long nose. Charles popularized his likeness to assert his authority during the Hundred Years' War, when England's kings also claimed the French crown. For example, his portrait appears in this book that recorded his elaborate coronation ceremony, a ritual designed to validate his power. In the picture, Charles receives spurs from the duke of Burgundy, who, unlike the king, is identified not by his likeness but by his coat of arms.

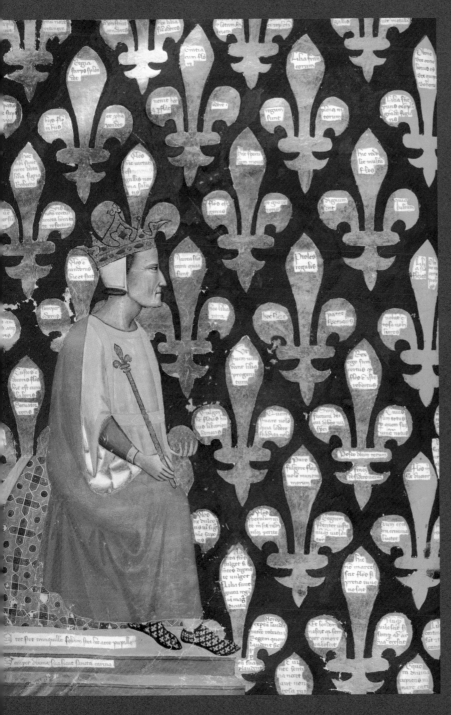

**Robert of Anjou, King of Naples,
Sitting on His Throne**
*Address to Robert of Anjou from the
Town of Prato in Tuscany*
Tuscany, ca. 1335–40
BL, Royal Ms. 6 E.IX, fol. 10v

This image portrays Robert of
Anjou (1278–1343), king of Naples,
enthroned, crowned, and bearing
a scepter and an orb. Silhouetted
against a flat field of fleurs-de-lis,
his family arms, the king's body has
a pronounced volume. Robert has
unique and identifiable features that
are repeated in other portraits, most
notably in Simone Martini's Saint
Louis of Toulouse altarpiece in Naples,
in which the king kneels at the saint's
feet. Such recognizable specificity was
new in the fourteenth century and
contrasted with images painted only a
few decades earlier.

# PORTRAITS OF THE PAST

Medieval artists were frequently asked to depict people from the past. Historical portraits include those of authors, heroes, rulers, and, above all, religious figures such as Christ and the saints. Because there was usually no record of what these people looked like, artists were free to invent their likenesses. While these portraits were fictional, they were far from meaningless; instead, they were designed to covey important information about their subjects.

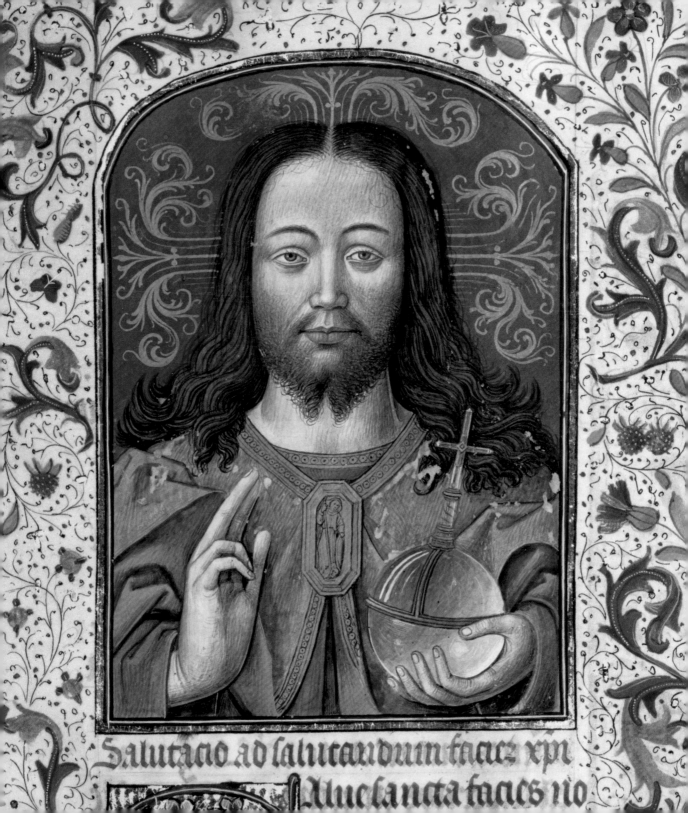

Salutacio ad saluraudum faciez xpi

Aue sancta facies no

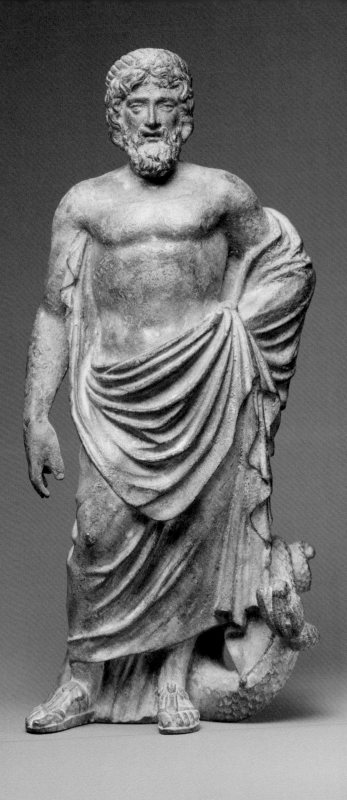

Artists typically invented these portraits by situating the subject within a broader category, and then using appropriate facial types, costumes, and attributes. Thus images of classical writers such as Plato and Aristotle served as models for portraits of the evangelists (Gospel writers Matthew, Mark, Luke, and John), while portraits of wise men and gods were the models for portraits of Christ. These invented likenesses also conformed to the broader standards of portraiture, as we can see by examining works that include portraits of historical figures and contemporaries in the same image (for example, fig. 8). As medieval viewers began to expect realism in images of their contemporaries, so too they began to want it in portraits of people from the past.

## CHRIST

We are so accustomed to thinking of Christ as a serious-looking man with long brown hair and a beard (fig. 19) that it comes as a shock to find that the Bible never describes his appearance. Faced with this lack of information, and anxious not to violate the second commandment's prohibition against graven images, some early Christians preferred symbols of Christ to portraits of him. In the end, though, the desire to see Christ's face overwhelmed these scruples. We owe our traditional vision of him to early Christian artists, who, in the absence of a biblical description, borrowed the beard and long hair from Roman depictions of philosophers and gods such as Asklepios, the healing deity (fig. 20). Such borrowings aligned Christ with the qualities of wisdom, divinity, and caring found in their sources. These early depictions gradually settled on a convention for Christ's appearance, which was to become the most influential imaginary portrait in Western history.

In fact, the resulting image was so successful that a late medieval writer incorporated it into a description that many then accepted as an eyewitness account. The apocryphal text, the so-called letter of Lentulus, reports that Christ's "hair is the color of a ripe hazel-nut. It falls straight to the level of his ears; from there down it curls thickly, and hangs down to his shoulders. His hair is parted in the center. His forehead is wide, smooth, and serene, and his face without wrinkles. His nose and mouth are faultless. His beard is thick, short, and parted in the middle. His eyes are brilliant. He is the most beautiful among men."

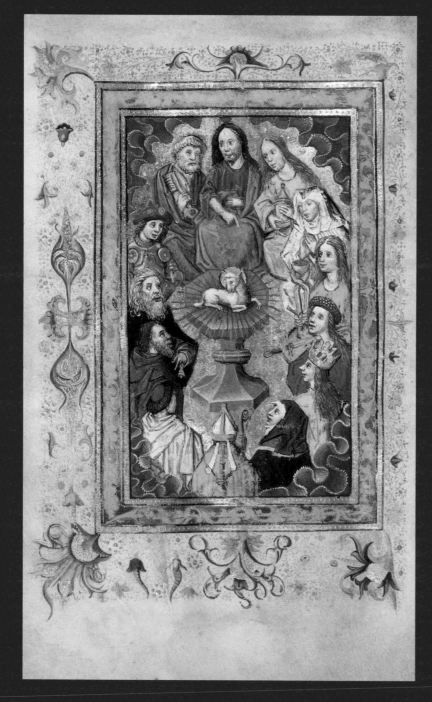

**21** ◁

**The Lamb of God with Saints**
Book of hours
Northern Netherlands, after 1460
JPGM, Ms. Ludwig IX 9, fol. 99v

John the Baptist announced Christ's
sacrificial role by naming him "the Lamb
of God, who taketh away the sins of the
world." Using John's metaphor, the earli-
est Christian artists depicted Christ as a
lamb in order to avoid the idolatrous wor-
ship that a human portrait might encour-
age. In 692, however, a church council
decreed that depicting Christ as a lamb
was potentially confusing and that Christ
should be shown in human form. Western
European artists, however, continued
depicting Christ as a lamb. One might
think of a baby sheep as shy, but this
cute, anthropomorphic lamb seems to be
preening and posing in response to being
the center of attention, thoroughly enjoy-
ing his moment in the spotlight.

**22** ▷

**Chi-Rho Monogram**
Lindisfarne Gospels
Lindisfarne, ca. 710–721
BL, Cotton Nero Ms. D.IV, fol. 29

John's Gospel begins, "In the beginning
was the Word, and the Word was with
God, and the Word was God." Given
Christ's status as the Incarnate word,
his name became a powerful sign of his
identity. Here, early medieval artists
lavished attention on the *chi rho*, Christ's
monogram, taken from the first two
letters of Christ's name in Greek. The
elaborate letters appear at Matthew 1:18,
the first verse in the Latin Bible to start
with Christ's name.

uutedlice
ruæt ðæt
cnyttcr cnou
ne ro

god lice

cynn þæt ecenre t eneuneriu        ruæt ður        peer        mid ðy

XPI autem generatio

RATIO XICERATCVM
peer                              bi poedded t beboden t bepeartnud t betaht

ESSET OESBONIXATA
moder                            lyr

MATER EIUS MARIA IC IOSEPH

togemanne
naller to hab
banne. æpir

abiathar
de aldormon
peer indem
tid in hieru
ralem. þone
biycob. he be
bead mania
ioyephe to
gemenne y
tobegeong
annt mid
claennyre.

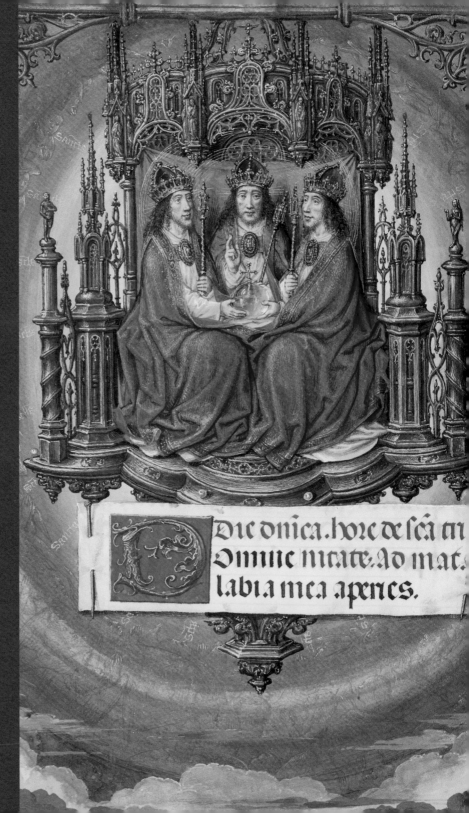

**23** ▷

**The Holy Trinity Enthroned**
Master of James IV of Scotland
Spinola Hours
Bruges and Ghent, ca. 1510–20
JPGM, Ms. Ludwig IX 18, fol. 10v

One of the most important beliefs of medieval Catholicism was that God has three persons (Father, Son, and Holy Spirit), united in one nature (the Trinity). Representing the Trinity—three distinct identities in a single entity—posed a challenge to artists. This miniature shows one solution. Their three separate bodies demonstrate that Father, Son, and Holy Spirit are distinct individuals, while their identical appearance conveys their unity. The depiction seems odd enough, but some artists went still further and portrayed the Trinity with a single body and three heads. Bishop Antoninus of Florence condemned artists for depicting such hydra-headed divinities, claiming that they were "monstrous in the nature of things."

## MIRACULOUS PORTRAITS

A number of medieval portraits were renowned for their wondrous origins. The best known of these was a portrait of Christ kept in Rome and known as the Veronica. It was said to have been produced when the pious woman Veronica wiped Christ's face on his way to his crucifixion at Calvary; removing the cloth, she found it imprinted with a perfect likeness of his features (fig. 24). Since this cloth's image was based on the actual body of Christ, it was regarded as a relic with miraculous powers; prayers said before the Veronica earned the devout viewer a shorter sentence in purgatory. Such famous portraits were reproduced frequently, and accurate copies were believed to share the original's power.

The earliest surviving depiction of the Veronica (fig. 25) was painted around 1240 by Matthew Paris, the same artist who had so painstakingly portrayed the

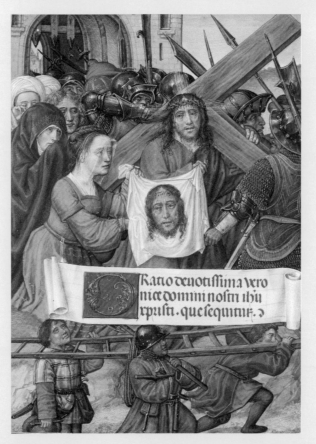

**24** ▷
**The Way to Calvary and Saint Veronica**
Master of James IV of Scotland
Spinola Hours
Bruges and Ghent, ca. 1510–20
JPGM, Ms. Ludwig IX 18, fol. 8v

25 ▷
**Veronica's Veil**
Matthew Paris
Prayer book
Southeast England, ca. 1240
BL, Arundel Ms. 157, fol. 2

royal elephant (fig. 9). Paris's Veronica reveals both the ambitions and the limitations of thirteenth-century realism: on the one hand, the artist celebrated the existence of Rome's authentic, accurate likeness of Christ; on the other hand, he never actually saw it, and the image's inscription admits its human invention: "To stimulate the mind further toward devotion, a face of Christ has been added by the trained hand of the artist." Thus, Matthew's image presents an imagined version of an authentic likeness.

Strikingly, these images received increasing veneration during the same centuries that saw such dramatic changes in the practice of naturalistic portraiture. And people of the late Middle Ages evaluated the images in novel terms of resemblance and plausibility. For instance, when Jacobus Pantaleone, later Pope Urban IV, sent a legendary portrait of Christ from Rome to his sister in France, he explained the dark skin of the portrait's

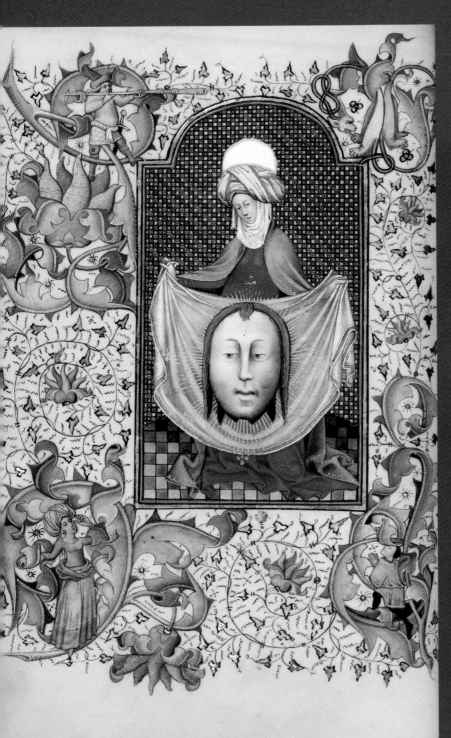

**26** ◁
**Saint Veronica Displaying the Sudarium**
Master of Guillebert de Mets
Book of hours
Probably Ghent, ca. 1450–55
JPGM, Ms. 2, fol. 13v

Here Veronica presents the cloth with Christ's portrait to the viewer. Christ's face appears to hover before the folded cloth, emphasizing its miraculous nature. The papacy decreed that reciting a certain prayer while gazing at the picture would earn viewers an indulgence, sparing them many years in purgatory. The text of the prayer often accompanies images of the Holy Face based on the Veronica. A later owner of the manuscript doubted Veronica's saintly status and carefully cut out her halo.

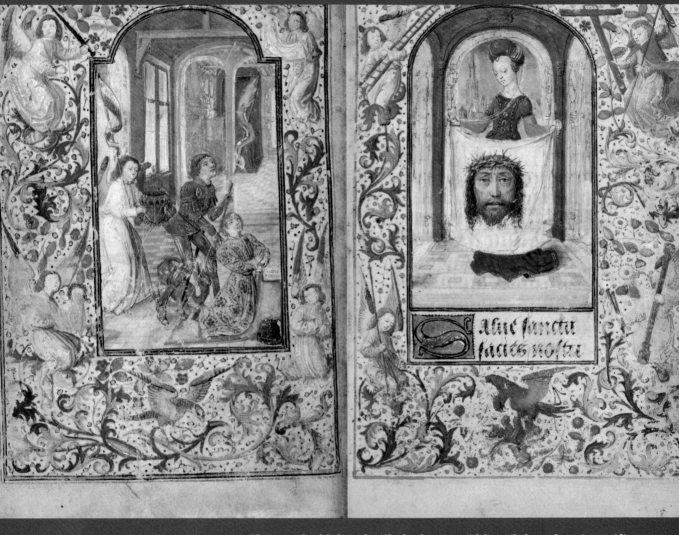

**27** △
**Charles the Bold Presented by
Saint George to Saint Veronica**
Lieven van Lathem
Prayer Book of Charles the Bold
Ghent and Antwerp, ca. 1471
JPGM, Ms. 37, fols. 1v–2

This prayer book belonged to Charles the
Bold, duke of Burgundy, and begins with
two facing pages that show Charles accom-
panied by his patron, Saint George, praying
before Veronica and her veil. The artist used
portraiture to engage the duke in a nuanced
series of visual encounters. If one imagines
Charles reading the book, he would see, to
the left, himself looking toward Veronica

with her veil; the modest saint, avoiding
the viewer with downcast eyes, and Christ
gazing directly out of the page, ignoring the
painted Charles across the book's gutter in
favor of the real duke holding the book.
The image held by Veronica, though but an
image on a cloth, possesses a detailed real-
ism and weight that the artist withheld from
the more conventional portrait of Charles.

subject as a natural consequence of his life in the sunny Holy Land: Christ's skin had been tanned by the sun.

Another set of legendary images were portraits of Mary attributed to Saint Luke the Evangelist. Luke's profession as a portraitist to the Virgin is not mentioned in the Bible, but the legend appears in Christian texts as early as the year 600. In the thirteenth century, Jacobus da Voragine incorporated the story into his *Golden Legend*, crediting Luke with painting "a perfect likeness" of the Virgin preserved in the church of Santa Maria Maggiore in Rome. Artists of the fourteenth century were the first to depict Luke as a painter, and many artists' guilds adopted him as their patron saint. Here, Luke paints a bust-length portrait of the Virgin Mary, framing Mary's features with a heavy blue veil against an abstract gold background on a small, round-topped panel (fig. 28). This portrait type is based on icons ("likeness," in Greek), which were objects of veneration for Christians in the eastern Mediterranean, known as Byzantium. During the later Middle Ages, Byzantine icons were imported in large numbers into western Europe. Because they were stylistically very different from Western portraits, they were thought to be exceptionally old and were often attributed to Saint Luke himself.

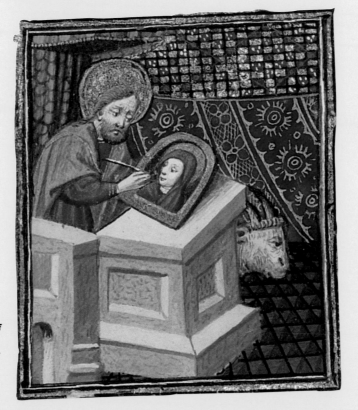

28 ▷
**Saint Luke Painting an Image of the Virgin**
Workshop of the Bedford Master
Book of hours
Paris, ca. 1440–50
JPGM, Ms. Ludwig IX 6, fol. 209

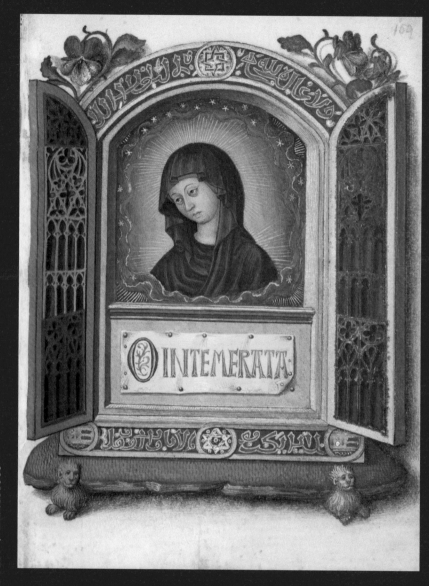

**Portable Altarpiece with the
Weeping Madonna**
George Trubert
Book of hours
Provence, ca. 1480–90
JPGM, Ms. 48, fol. 159

Mary's mournful expression and deep blue
veil are typical Byzantine elements, indicat-
ing that this French portrait of the Virgin is
modeled on a Byzantine icon. Byzantine icons
enjoyed enormous prestige in western Europe
as authentic likenesses of holy figures; as a
result, many icons were copied by western
artists. This miniature is a picture of a
picture, complete with a frame inscribed
in pseudo-Arabic, and probably depicts a
famous icon kept in southern France and
copied in several contemporary manuscripts.

**30** ▷
**The Virgin and Child**
Jean Fouquet
Hours of Simon de Varie
Tours, 1455
The Hague, Koninklijke Bibliotheek,
Ms. 74 G 37, fol. 1v

Jean Fouquet modeled his portrait of the
Virgin and Child on the Byzantine icons so
valued by his contemporaries, borrowing the
deep blue cowl covering Mary's head. But
while Fouquet refers to those icons, he trans-
lates their elements into his own unique style,
creating a portrait with recognizably ancient
roots and a distinctly modern appearance. In
effect, like much devotional portraiture, the
image collapses time, inviting us to imagine
that the same woman who had posed for
Luke in the time of Christ had appeared in
fifteenth-century France to pose for Fouquet.

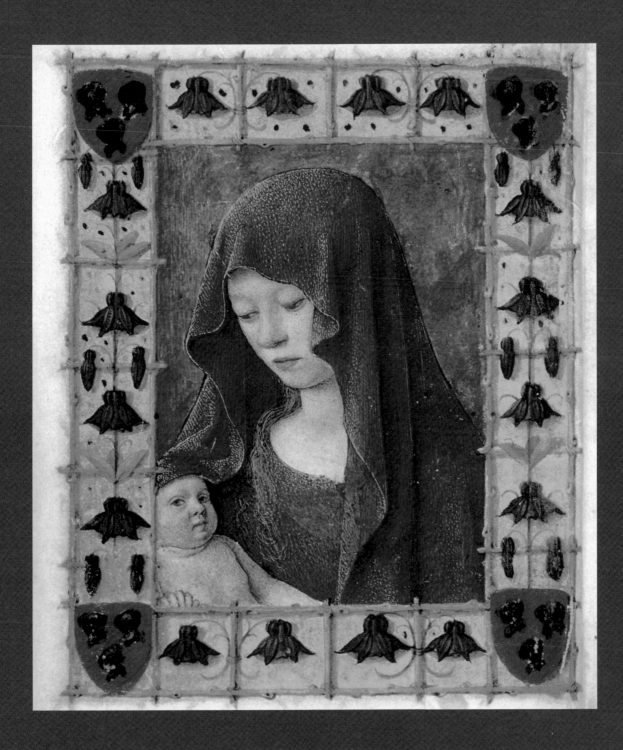

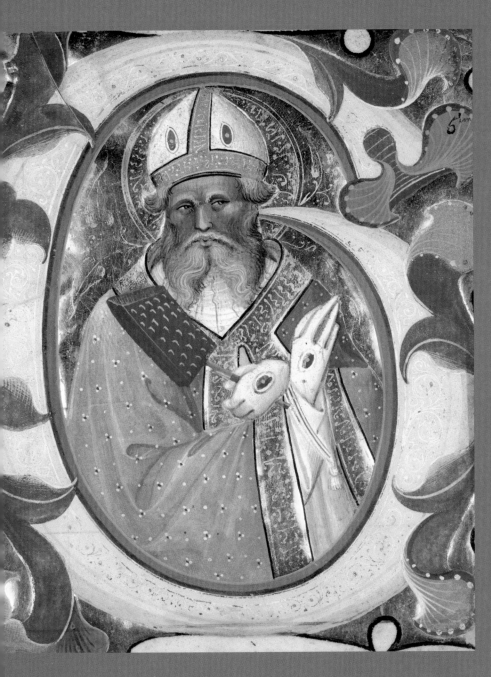

**Initial G: Saint Blaise**
Master of the Murano Gradual
Cutting from a gradual
Venice, ca. 1450–60
JPGM, Ms. 73, recto

Saint Blaise, an early Christian
martyr, is identified by his bishop's
miter. Like many martyrs, Blaise
was beheaded with a sword;
however, here he holds the carding
comb (for wool) that was used to
torture him prior to his death. It is
an unusual instrument of martyr-
dom, one that identifies him more
securely than would a sword.

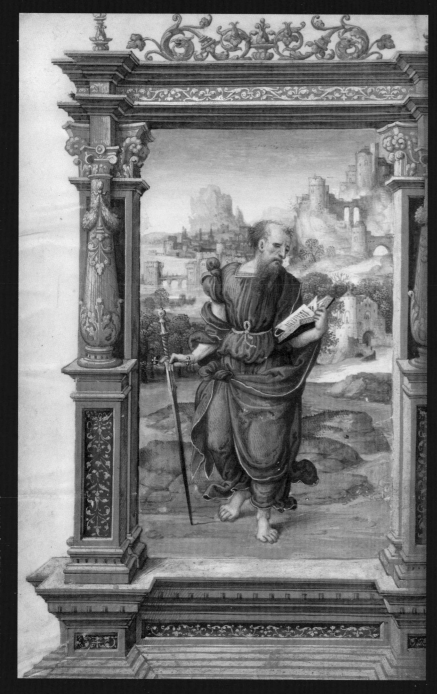

**34** ◁
**Saint Paul**
Master of the Getty Epistles
Getty Epistles
France, ca. 1520–30
JPGM, Ms. Ludwig I 15, fol. 5v

Paul stands in a deep landscape holding a sword, an emblem of his martyrdom by decapitation and his traditional attribute. The saint has the standard features assigned to him throughout medieval and Renaissance art: he is mostly bald, with a long, straight beard, his imposing forehead bears a prominent tuft of hair, and he has a long nose. These features, which derive from Roman portraits of philosophers, were assigned to Paul to allude to his great wisdom.

**35** ▷
**Saint Bernardino of Siena**
Taddeo Crivelli
Gualenghi-d'Este Hours
Ferrara, ca. 1469
JPGM, Ms. Ludwig IX 13, fol. 195v

Saint Bernardino of Siena (1380–1444), a renowned preacher, invented the emblem of IHS—the first three letters of Jesus' name in the Latin alphabet, transliterated from the Greek—that floats before him. Though this attribute identifies the saint, he also has a recognizable face. Bernardino's likeness was documented by artists during his lifetime, allowing later painters to depict him with some accuracy. Portraits show a gaunt, aged saint with sunken cheeks and prominent cheekbones.

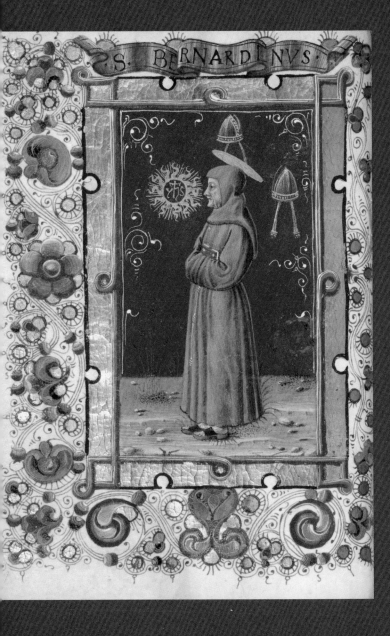

**36** △
**Saint Peter Martyr**
Taddeo Crivelli
Gualenghi d'Este Hours
Ferrara, ca. 1469
JPGM, Ms. Ludwig IX 13, fol. 192v

Peter Martyr was a Dominican friar who preached against heretics in Italy. In 1252, the heretics hired assassins who struck him in the head before stabbing him through the chest. Peter was declared a saint a year later. Here he stands in prayer, identified by the instruments of his martyrdom and his Dominican habit of a black, hooded cape over a white tunic. While modern viewers may find Peter oddly nonchalant about the hatchet in his head and the sword in his chest, medieval Christians believed that the saints in heaven would bear the marks of their earthly martyrdom.

## WRITERS

One of the oldest categories of portraiture, author portraits were produced in antiquity, the Middle Ages, and today (think of the back of a hardcover book), and they thus offer an excellent record of the evolution of portrait conventions. In general, their purpose was to make clear that the author's work was trustworthy. Take, for example, the author portraits in Eadmer's biography of Saint Anselm, written around 1120 (fig. 37). The biography is divided into two sections; reversing our expectations of biographies, the author is portrayed twice, at the beginning of each section, and the subject—Anselm—not at all. In fact, Eadmer does not even describe Anselm's features, focusing instead on the saint's sanctity and wisdom. The book's artist was similarly unconcerned with Eadmer's actual appearance, concentrating instead on his status. The resulting portrait of Eadmer draws on traditional models, most notably portraits of the evangelists, to align his new biography with the hallowed, authoritative texts of the Church. The artist enhances Eadmer's authority by enthroning him beneath a canopy and shows him with a tonsure to indicate that he was a monk. As Eadmer gazes at his text, his brow is furrowed by a single, U-shaped line conveying the effort required by his thoughtful labors.

37 ◁
**Eadmer of Canterbury**
Eadmer of Canterbury, *Life and Conversation of Anselm of Canterbury*
Probably Tournai, ca. 1140–50
JPGM, Ms. Ludwig XI 6, fol. 44v

38 ▷
**Saint Luke**
Gospel book
Helmarshausen, ca. 1120–40
JPGM, Ms. Ludwig II 3, fol. 83v

Luke sharpens his quill after writing the first words of his Gospel, which appear on the scroll in front of him. Although the artist had no record of Luke's appearance, the evangelist's figure here is quite expressive. Luke sits bolt upright, and his crossed legs, pointed toes, and rhythmically creased robe create a coiled energy that flows upward to his poised, subtle hands. His face, emphasized by a halo, features large eyes, firm brows, and a forehead creased in concentration. An inspired author, Luke receives God's word with the rapt, attentive air of a careful scribe.

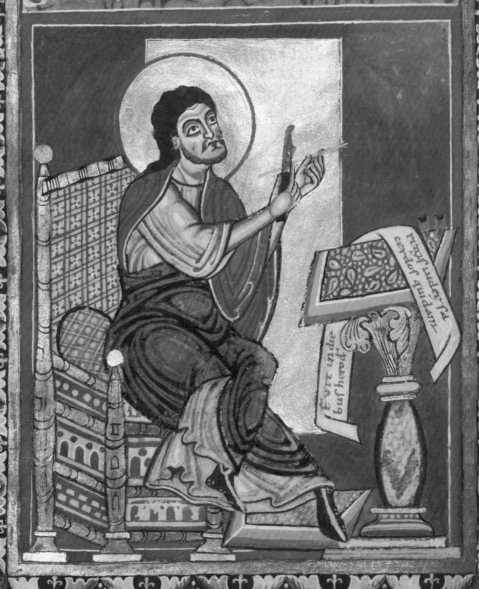

INCIPIVS SCI EVANGELII
SCO M · LVCAM ·

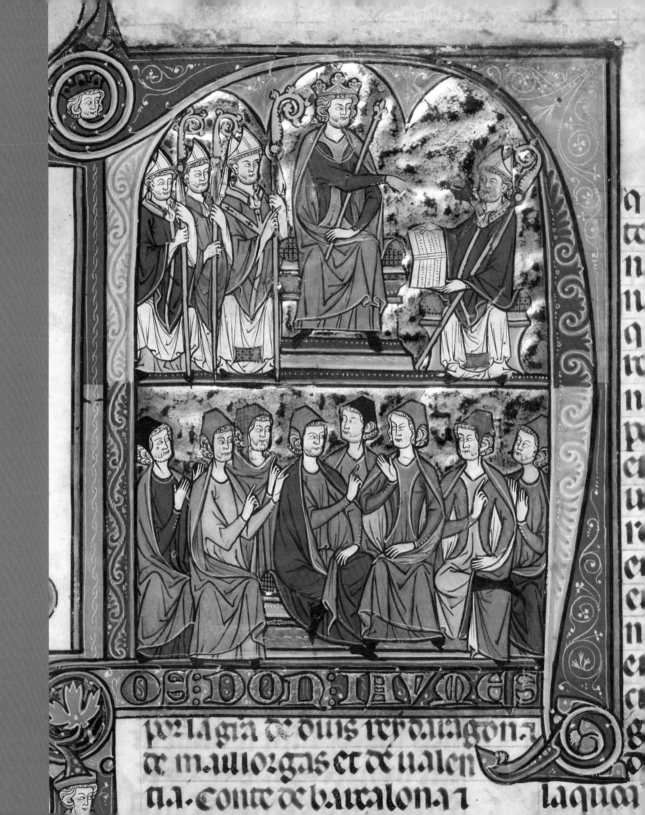

**Initial *N*: Vidal de Canellas Offering
His Text to King James**
Vidal de Canellas, *Feudal Customs
of Aragon*
Northeastern Spain, ca. 1290–1310
JPGM, Ms. Ludwig XIV 6, fol. 1

The *Vidal Mayor* is a translation of a Latin
law text that Vidal de Canellas, bishop of
Huesca, wrote for James I of Aragon and
Catalonia in 1247. Here Vidal presents the
book to King James, who points to the open
volume in the translator's hands. While
book presentations climax with the
delighted patron accepting the beautiful
tome, presentation pictures usually place
the book in the author's hands to under-
score his initiative in the ceremony. This
was particularly important in cases like this
one, where a modest author presents a book
to a mighty king; if the king were already
holding the book, we wouldn't even notice
the author.

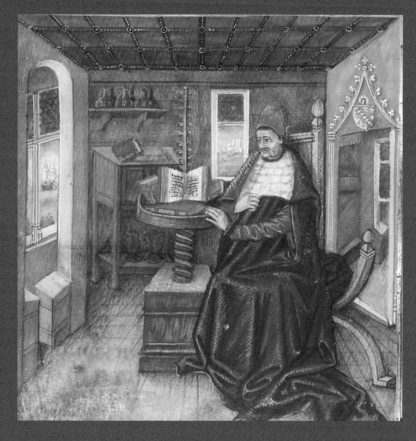

40 ◁

**Marcus Terentius Varro in
His Study**
Master of the Oxford Hours
Saint Augustine, *City of God*
Nantes, ca. 1440–50
JPGM, Ms. Ludwig XI 10,
fol. 173

The pagan author Varro (116–27 B.C.)
wrote widely on philosophy, grammar,
and agriculture, works for which Augus-
tine praised him as "the most learned of
Romans." Varro was also a hero to the
Renaissance humanists who admired
ancient Rome; thus Petrarch praised:
"Varro, who was still reading and writing
at one hundred, gave up his life before his
love of studies." This book's owner linked
himself with Varro by including his own
coat of arms above the door at the right.

While sacred authors usually hold
just one book, Varro has many in his
well-equipped study. Similarly, while
evangelist portraits usually emphasize
divine inspiration, Varro's gaunt cheeks,
jowly chin, and puffy eyes show the strain
of too much reading. The realistic empha-
sis on the face's texture and musculature
marks an important break with earlier
conventions.

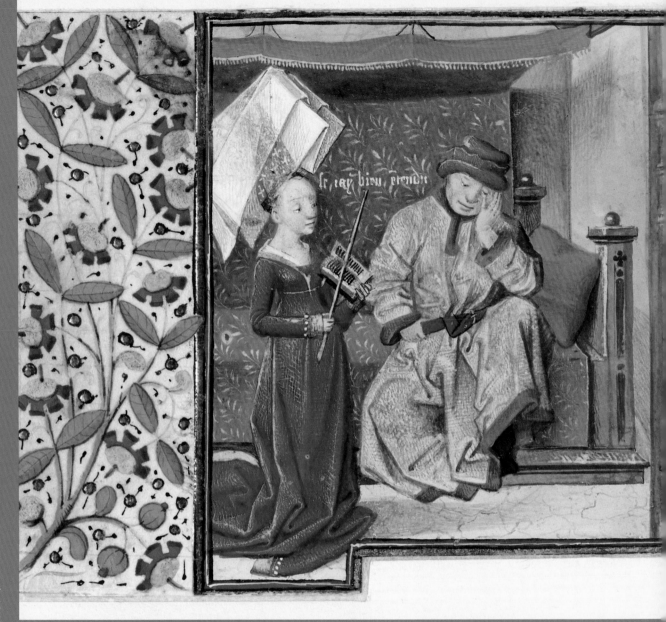

**41**
**Philosophy Consoling Boethius and Fortune Turning the Wheel**
Coëtivy Master
Miniature from Boethius, *On the Consolation of Philosophy*
Paris, ca. 1460–70
JPGM, Ms. 42, leaf 1v

Boethius was a sixth-century scholar and politician who was condemned by the emperor Theodoric for conspiracy. While in prison, he wrote the *Consolation of Philosophy*, a moral and philosophical treatise popular throughout the Middle Ages

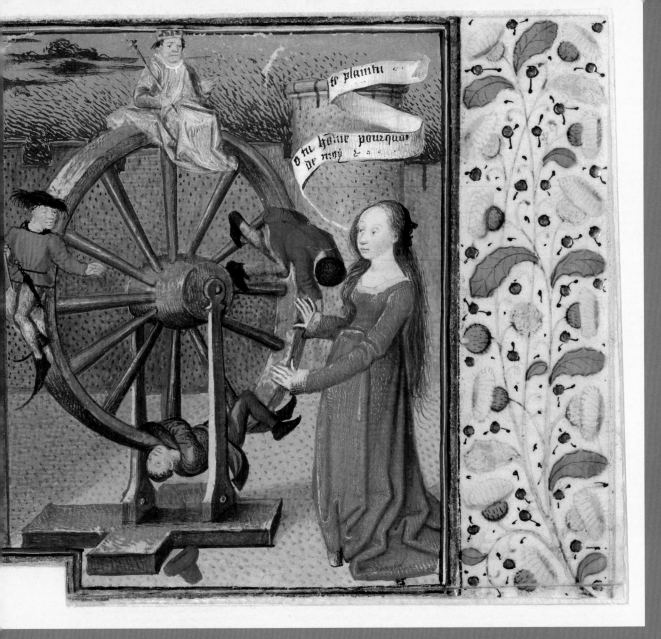

On the banner: *tr plainti* / *O fu halue pourquas / pe moy & c*

and Renaissance. According to the text, Philosophy herself appeared to Boethius in prison, rallying him from despair. Here she describes Fortune's fickle ways to the downcast author, while Fortune personified spins her wheel at the right. The proud king at the top sits in apparent security, but will soon share the fate of his hapless companions on the wheel, tumbling down like the man at right before holding on for dear life like the man at the bottom.

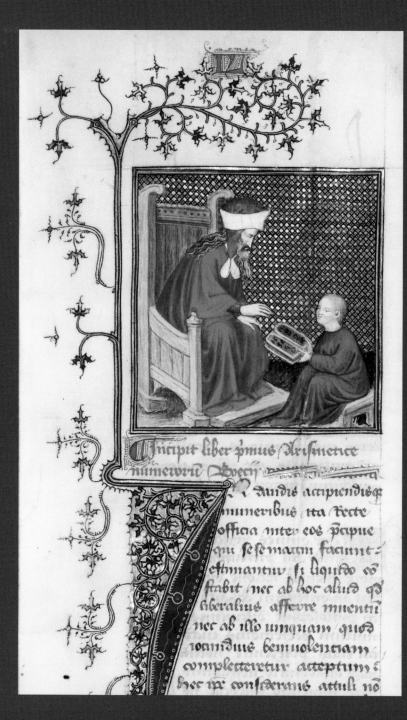

42 ◁

**Boethius Instructs a Young Boy
in Arithmetic**
Virgil Master
Boethius, *Concerning Arithmetic*
Paris, ca. 1405
JPGM, Ms. 72, fol. 26

43 ▷

**Boethius Discusses Music**
Virgil Master
Boethius, *Concerning Music*
JPGM, Ms. 72, fol. 69

In addition to the *Consolation of Philosophy*,
Boethius wrote important texts on music and
mathematics that were read for centuries to
come. He appears several times in this manu-
script of his works, wearing the robes of a
medieval professor and occupying a chair
that symbolizes academic authority. In the
first image, Boethius instructs a single youth
in mathematics; in the second, he lectures
to a larger class on music, with a diagram of
musical forms floating mysteriously in the
image's center.

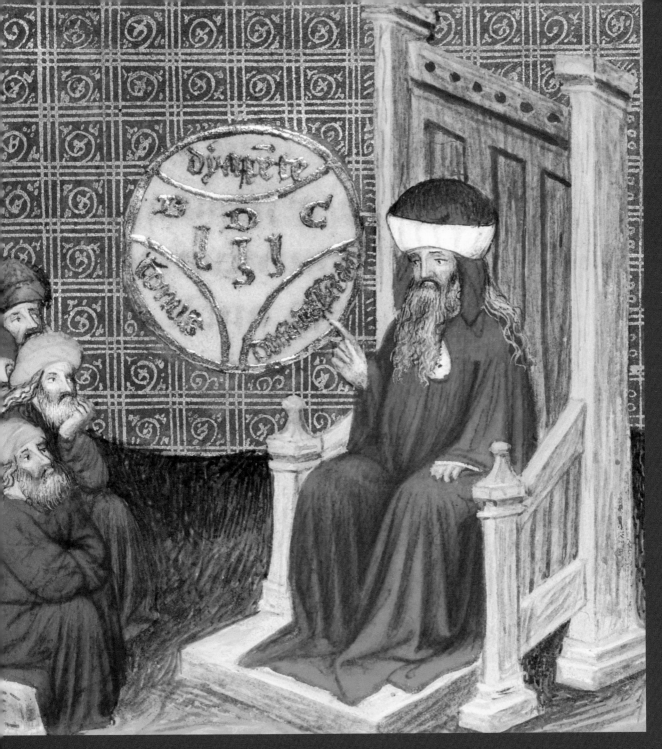

# IVLII CESARIS COM[M]
# R̄V̄ DEBEL̄ GALLO LIBE̅R̄ P̄M̄
# CITER

## ALLIA EST OM[NIS]

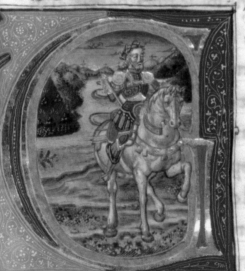

in partes tres quarum un[a]

alteram aquitani tertiam [qui]

celte nostra galli appellar[tur]

institutis legibus inter se di[ffe]

tans garunna flumen a b[elgis]

quana diuidit. horum o[mnium]

sunt belge propterea qd[quod]

tutate prouincie longissim[e]

ad eos mercatores sepe commeant atq[ue] ea que ad effe[mi]

tment important proximi sunt germanis quitran[s]

quibus continenter bellum gerunt qua de causa hel[uetii]

gallos uirtute precedunt qd[quod] fere quotidianis prelii[s]

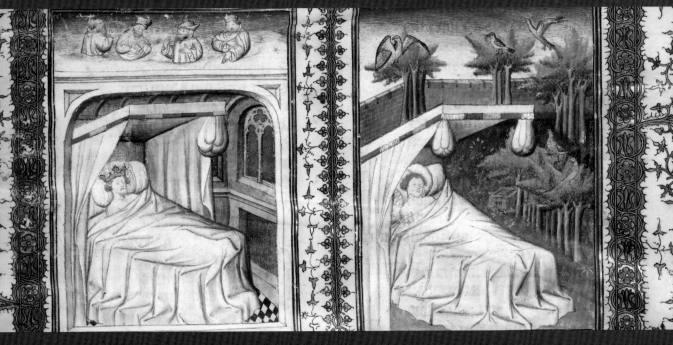

**44** ◁
**Initial *G*: Julius Caesar on Horseback**
Julius Caesar, *On the Gallic War*
Florence, ca. 1460–70
JPGM, Ms. Ludwig XIII 8, fol. 2

Caesar's *On the Gallic War*, a record of his
conquest of Gaul (now France), was prized
during the Renaissance as an elegant Latin
account of a famous man's martial prowess.
This copy opens with an initial *G* containing
Caesar's portrait. Though Caesar is the au-
thor of the text, the artist avoids traditional
author-portrait iconography. Instead, he
depicts Caesar on horseback, imitating the
equestrian portraits that celebrated military
greatness in antiquity. Caesar also carries a
baton to indicate his authority and sports
the victor's laurel wreath on his head.

**45** △
**Scipio Lying in Bed Dreaming and**
**Guillaume de Lorris Lying in Bed Dreaming**
Guillaume de Lorris and Jean de Meun,
*Romance of the Rose*
Paris, ca. 1405
JPGM, Ms. Ludwig XV 7, fol. 1

Guillaume de Lorris's *Romance of the Rose*
was the most important French poem of the
Middle Ages. An allegorical love poem, it
is cast as the record of a dream that came
to Guillaume in his sleep. So, while we are
not used to seeing authors in bed, that is
exactly how this book starts: with the author
dreaming in the bed at right. To vouch for
the authenticity of his dream and double the
page's somnolent fun, the artist has painted
another dreamer at left: Scipio, the ancient
Roman leader who dreamed of conquer-
ing Carthage, which he did, proving that
dreams can be prophetic.

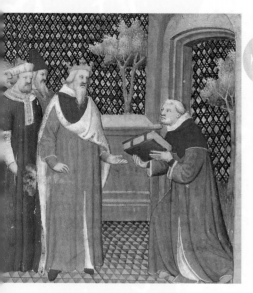

*Concerning the Fates of Illustrious Men and Women* by Giovanni Boccaccio
Boucicaut Master and Workshop
Paris, ca. 1415
JPGM, Ms. 63

**46** △

**The Presention of the Book to a King**, fol. 1

The manuscript's first picture shows an author in scholarly garb presenting a book to a king, relying on the traditional iconography of manuscript presentation (see also figs. 39 and 53). It is not clear which royal patron the picture represents. Boccaccio dedicated his text to Mainardo Cavalcanti, a member of an important Florentine family. The French version of the text in this manuscript is the work of Laurent de Premierfait, who dedicated his translation to Jean, duke of Berry. While both Mainardo and Jean were important figures, neither was a king. Thus, it seems possible that this presentation scene is designed not to depict a specific dedication, but instead to promote the status of the author and his work by suggesting ties to important people in society.

## A WRITER IN FOCUS: **GIOVANNI BOCCACCIO**

Giovanni Boccaccio is best known today for the *Decameron*, a collection of sometimes bawdy tales, but in fifteenth-century France more people read his *Concerning the Fates of Illustrious Men and Women*, which compiled the tragic biographies of famous people in history. Boccaccio wrote the book to show how Fortune acted in people's lives, raising them to glory on her rotating wheel before lowering them to their doom. In writing the book, Boccaccio drew on his broad reading of history; to establish his authority, the book's illustrators drew on the many traditions of author portraits.

**47** ▷

**The Story of Adam and Eve**, fol. 3

Boccaccio's text begins with Adam and Eve, who appear to him with the request that he record their story. The book's first large miniature features a monumental and impressive depiction of Paradise. Like a medieval precursor to cinematic narration, we see all the important episodes of their story: in the center they are tempted by the snake in Paradise; after succumbing to the serpent's wiles, they are expelled by an angel (at left), and are forced to work for their living (in the background), with Adam tilling and Eve spinning; visibly aged by their hard labors, the two reappear (right foreground), hunched over and leaning on canes for support, as they approach Boccaccio to tell their story. Boccaccio sits in a high-backed chair, a traditional seat for a scholarly author.

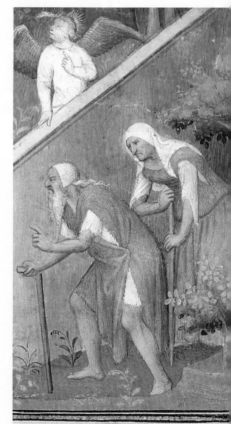

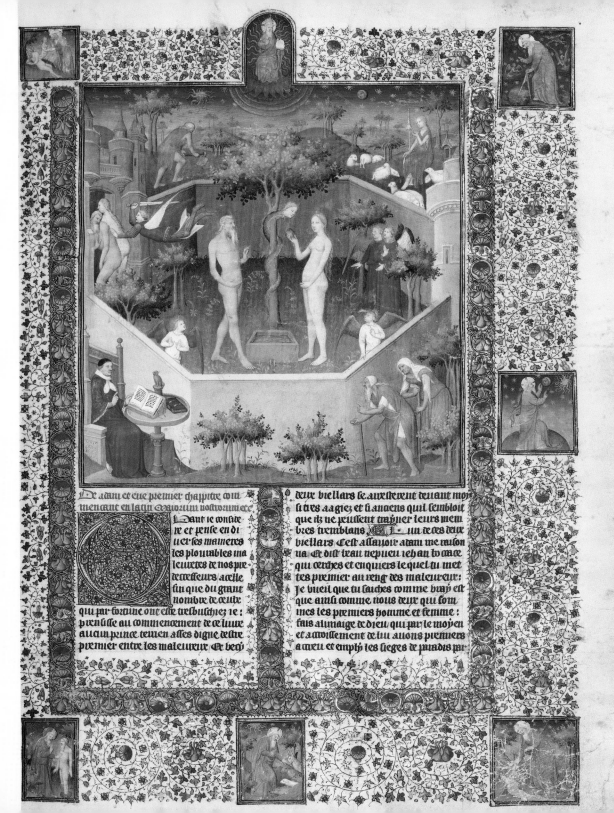

De adam et eue premier chapitre com
mencant en latin Qui cum nostrouim ere

Quant ie consi
re et pense en di
uerses manieres
les pitoiables ma
leurtes de nos pre
decesseurs a celle
fin que du grant
nombre de ceulx
qui par fortune ont este trebuschiez ie
pruisse au commencement de ce liure
aucun prince renen asses digne destre
premier entre les maleureux. Et veci

deux vieillars se auexerent deuant moy
si tres aagiez et si anaens quil sembloit
que iz ne peussent trayner leurs mem
bres tremblans. Lun de ces deux
vieillars Cest assauoir adam me raison
na. Et dist Bean nepueu iehan boace
qui cerches et enquiers le quel tu met
tes premier au reng des maleureux:
Je vueil que tu saiches comme bray est
que ainsi comme nous deux qui som
mes les premiers homme et femme:
fais aumaige de dieu qui par le moyen
et a uoisement de lui auons premiers
a creu et empli les sieges de paradis par

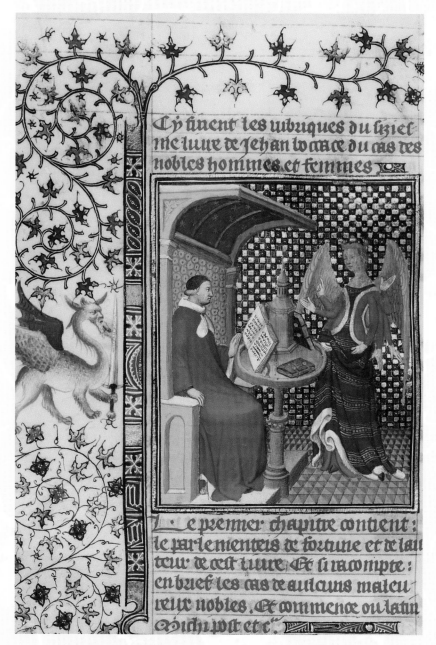

**48** ◁

**Boccaccio and Fortune**, fol. 172v

In this scene the personification of Fortune appears to Boccaccio, who looks up from the book on his rotating lectern. Boccaccio's account of Fortune's visit is analogous to the vision of Boetheus (fig. 41). Here, Fortune is depicted not with her wheel but with seven arms, another representation of her capriciousness. To us, Fortune may appear comical rather than terrifying, but one of the book's previous owners took her threat so seriously that he rubbed out her face as if to render her powerless.

**49** ▷

**Boccaccio's Vision of the Laurel-Crowned Petrarch**, fol. 243

*Concerning the Fates of Illustrious Men and Women* is an enormous work, and Boccaccio records that once, overwhelmed by the immensity of his task, he gave up writing and took to his bed. The humanist author Petrarch, his friend and mentor, appeared to him in a dream and admonished him to continue his labors. Their encounter is depicted here, drawing on the dreaming-author iconography already pioneered by the *Romance of the Rose* (fig. 45). Boccaccio describes Petrarch as looking pale and joyous, a description that the artist did not follow. However, he does include Petrarch's other attributes: his scholar's robe, and, most importantly, the laurel wreath encircling his head. Petrarch had been awarded the laurels for his poetry in Rome in 1341. Rewarding great deeds with a laurel crown revived an ancient practice; Caesar wears the same attribute in contemporary miniatures (fig. 44).

pur accomplir mon boulume. Toute
hores ie gisole comme vainat et pour
ui et disoie a moy mesmes. Cer
tes ich an vocace tu nas mie senten
ent pur quoy tour mentes tu ton corps
et ton engin par si grant trauueil que
iour et nuit ti trauueilles en uuiant
continuelment les liures des vieilx
hystoriens Et si ne es pas constreint
au grant labour emprendre. Ie moy
ich an vocace alongir des iours et
ton nom par la renommee que tu
penses acquerir par la faction de ton
liure en quoy tu descris en petit et
bas langaige les desrochemens des
nobles et anciens hommes Et
certes ich an vocace ceste couuoitise
est forsenee. Car la leure de la mort
venira et ia est venue que ton ame
partira de cestui mortel monde Cel
te heure de la mort confouuisera ton
corps et le muera en cendres. Ie te
prie ich an vocace aduise toy et
quoy tu demandes. Car pour tou
tes tes besoingnes transitoires et
mondaines tu ne auras aucun aul
tre plus grant salaire de honneur
ne de delectacion fors que le salaire
de renommee. Combien que tout
le monde aptenne touche ne chan
tast aultre chose fors que les louen
ges de toy et de tes faits. Cer
tain est ich an vocace que toutes
choses mondaines perront quant
le corps de la figure par quoy tu es
congneus trauldra. Ie ne dy pas
que ta renommee puisse pour qui
tu apprestes grans et nobles meurres
afin que elle soit honnouree receue
qui apres toy uendront. Car ta re
nommee pourra estre commune
a maintes gens Et par aduenture
ton nom est ia commun. Se ton
nom ia de fait est commun ou se
ou temps aduenir il doit estre com
mun. Uray est que tu trauuelles
pur aultrui aultre tant que pour

Le premier. Chapitre contient
ung relat te francois petrac quuelle
flourentin et de jehan vocace acteur
de cestuy liure. Et commence ou la
tin. Quid siquam et e.

E ne say quoy
ie die apres la
complissemet
de mon viii. li
ure fors que ie
me repose. mais
ie retreng le
repos. Car de
re chose est que le trop grant repos
est cause de encommisseur. Et si est
repos contraire a soubtilite dengin.
Et combien que par ma follie
ie aye espuuiue quele chose est repos
Toutesuoies ie suis maintenant de
uus en domuiageuse peresse. Car
pur ce que ie desiuoye repos ie aban
tonnay mes membres et les laissay
droux en tres grant oisiuete Ie ou
bliay toutes les buides de aisancons
et me plongay en si grant et si par
fond dormir que ie qui estoie requoy
semblove estre mort taut a moy
comme a aultre. Et la soit ce que
aulcune fois quant ie estoye escueil
lie que la aisancon du trauuel que
uay entreprins me uappellast pour

53

# PORTRAITS OF THE PRESENT

In medieval and Renaissance manuscripts, most portraits of living people have a religious function, showing the subject—often the owner or the donor of a book—in prayer before Christ or a saint. By inserting the owners into sacred narratives, such portraits collapsed time and space, enabling people to imagine themselves witnessing important religious events or standing before their favorite saintly figures to ask for help or guidance. The desire to experience these events as vividly as possible contributed to the growing realism of later medieval art.

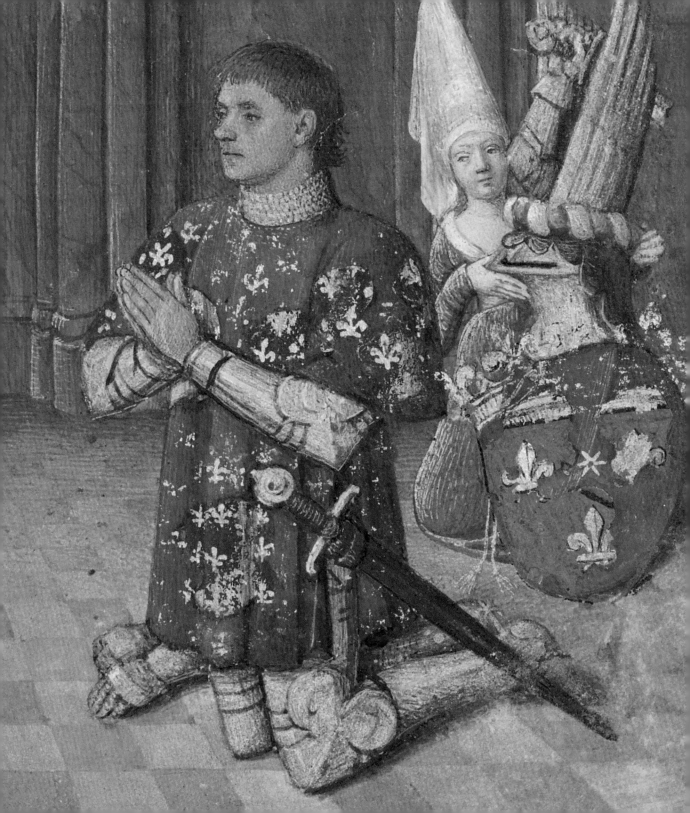

## DONORS

Gifts played an important role in medieval and Renaissance society, serving to establish and strengthen ties between individuals, families, and larger groups, from monasteries to nations. To function this way, gifts had to be memorable and highly personalized, and portraiture could play a substantial role in the exchange. Donors sometimes even included portraits of themselves along with their gifts, so that the recipients would remember them.

50 ▷
**King Cnut and Queen Emma Present a Golden Cross**
*Book of Life* of Newminster and Hyde
Winchester, ca. 1031
BL, Stowe Ms. 944, fol. 6

This book commemorates donors to the Benedictine monastery at Winchester. In its first image, Queen Emma and King Cnut place a great gold cross on an altar. The figures are identified with labels because their faces are conventional, rendered with the same firm but lively lines used in the faces of the other figures, including Mary, Christ, and Peter above, and the community of monks in the arcade below. Emma's face and pose echo Mary's, creating parallels between the earthly and celestial queens.

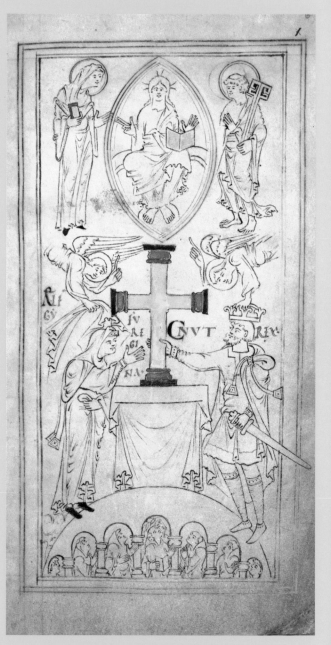

eiusdem Philippi ad idem opus. C·s·
Rogus Hoper ⁊ uxor eius Margeria contule
runt ad idem opus. lx·vj·s·⁊ viij·d·
Dns Thomas ffiting miles contulit ad idem
opus decem libras·

Dns Johannes Loukyn ca
nomicus ecctie que est london
apud Elsyng spitel·⁊ executor
Ade Loukyn·contulit p am
ma eiusdem Alde ad idem opus· xx· Marcas·
Dña Blancha Bake legauit Conuentui p pitan
cia· lx·s·
Ibittus ffhmmer legauit Conuentui· C·s·· et fabrice
ecctie· C·s· et lumini capelle sancte Marie ⁊ marc
Magister Johes Enderby legauit cuilibet mocho· xij·d·
Galfridus Stukle legauit Conuentui· C·s·
Alanus Strayler circa depictione
presentis libri plurimu laborauit· ⁊
tres solidos ⁊ iiij·d· sibi debitos p colo
ribz condonauit.

nome pictoris· Alan Strayler dictur
Qui su fine chons· celestib; associet v·

**Benefactors of Saint Albans Abbey**
Alanus Strayler
Golden Book of Saint Albans
England, ca. 1380
BL, Cotton Nero Ms. D.VII, fol. 106

This self-portrait of Alanus Strayler appears at the bottom of the page in a benefactors' book that he painted for Saint Albans. The book celebrated the generosity of those people who had donated money, land, and precious objects to the monastery throughout its history. Most of the donors portrayed in the book enjoyed a much higher rank than the artisan Strayler; they include English queens and important bishops. Strayler's artistic talent permits him to join their distinguished company; in the picture, the simply dressed Strayler points to an inscription recording that he donated the materials he used to decorate the book, thus becoming a benefactor as well. The inscription at the very bottom of the page indicates that in return for his generosity, the monks of Saint Albans will pray for him.

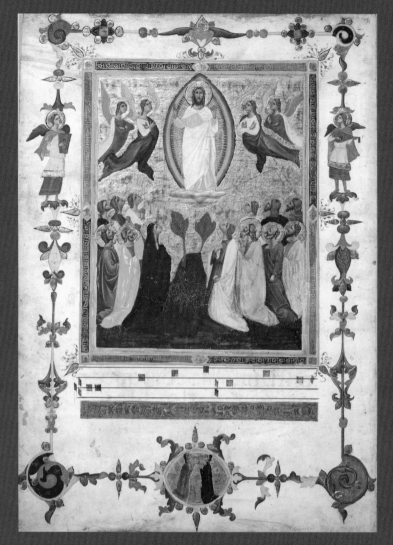

**Christine de Pisan Presenting Her Book to the Queen of France**
Master of the Cité des Dames and Workshop
Christine de Pisan, *Letter to Queen Isabelle*
Paris, ca. 1410–11
BL, Harley Ms. 4431, fol. 3

Christine de Pisan was the first woman to make her living as a writer in France. Her novel role required substantial initiative on her part, and portraiture played an important part in her self-presentation. This image opens a volume of her collected works that she gave to Isabelle of Bavaria, queen of France. Christine kneels in the queen's chamber, which is decorated with the arms of France and Bavaria, offering the massive volume with both hands. Although the artist probably knew Christine, he did not attempt a recognizable likeness of her face, which is identical to those of the queen and her attendants. Instead, Christine had him convey her identity through her clothing, which is fashionable but less showy than that of the aristocratic ladies present, and her pose, the traditional gesture of an author presenting a book to a patron.

**52** △
**The Ascension of Christ**
Pacino di Bonaguida
Leaf from the Laudario of Sant'Agnese
Florence, ca. 1340
JPGM, Ms. 80a , recto

This depiction of Christ's ascension appears in a laudario, or hymnal, owned and used by the Company of Saint Agnes, a group of men and women who worshiped together at the church of Santa Maria del Carmine in Florence. The two figures in the border's lower central roundel represent members of the company; these are not portraits of specific members, but generic representations with which those who used the book could have identified.

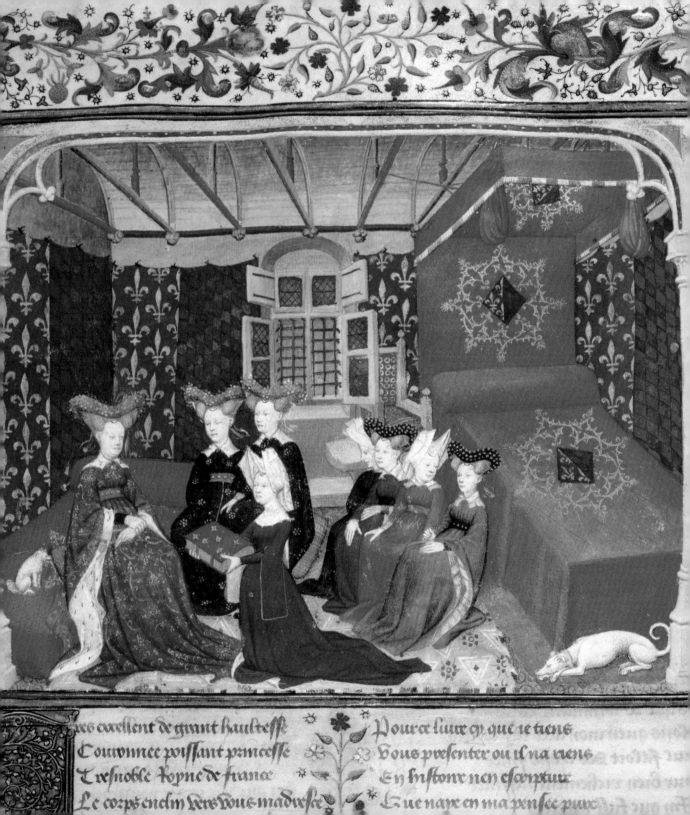

es excellent de grant haultesse
Couronnee poissant princesse
Tresnoble Royne de france
Le corps enclin vers vous madresse

Pour ce liure cy que ie tiens
Vous presenter ou il na riens
En histoire nen escripture
Que naye en ma pensee pure

## COATS OF ARMS

Twelfth-century armies invented heraldry to identify knights hidden by their helmets, and heraldry served a similar purpose in assigning a specific identity to a generic portrait. From these practical beginnings, heraldry became an important way of advertising a family's prestige (fig. 54). Only noble families could wear arms; the right to bear a particular coat of arms was a privilege granted by kings, one that was proudly preserved by succeeding generations as a sign of their power and status.

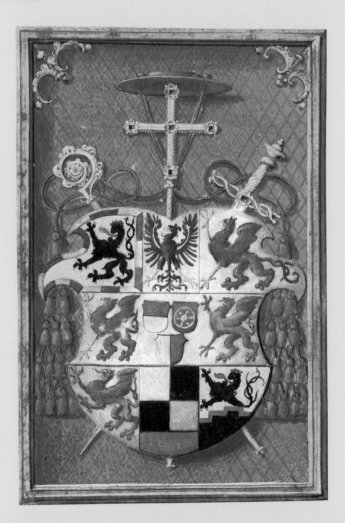

**54** ◁
**Blazon of Cardinal Albrecht of Brandenburg**
Simon Bening
Prayer Book of Cardinal Albrecht of Brandenburg
Bruges, ca. 1525–30
JPGM, Ms. Ludwig IX 19, fol. 1v

**55** ▷
**Letters Patent of King Edward IV, Granting Arms to Louis of Bruges, Earl of Winchester**
Westminster, November 23, 1472
BL, Egerton Ms. 2830

With this royal charter, issued in 1472, Edward IV of England gave Louis de Bruges the right to wear these arms as the duke of Winchester. The document proclaims the king's identity in several ways in addition to Louis's arms. It opens with a masterful inscription of his name, the *E* decorated with the Rose of York, and prominently displays Edward's Great Seal on a cord at bottom. Like heraldry, the practice of sealing documents began in the twelfth century, and seals became important tokens of both individual and institutional identity.

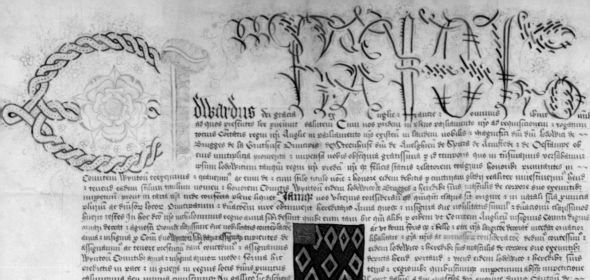

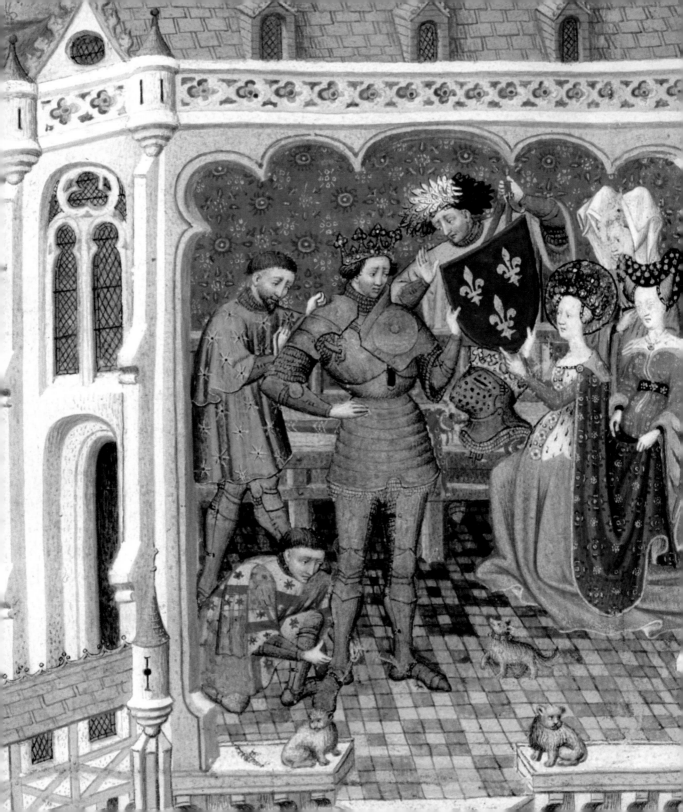

**56**
**The Legend of the Fleurs-de-Lys**
Master of the Munich Golden Legend
Bedford Hours
Paris, ca. 1414–23
BL, Add. Ms. 18850, fol. 288v

French national mythology held that unlike other coats of arms, which were human inventions, the royal fleurs-de-lis, or lilies, were God's gift to Clovis, France's first Christian king. This miniature shows an angel bringing the lilies to a hermit, who delivers them to Clovis's wife, Clotilde, who in turn presents them to Clovis. The picture appears in the Bedford Hours, belonging to John, duke of Bedford, the English regent in France, who wore the lilies to promote England's claim to the French throne.

Deqrteno.p.sci.peuli.

**Saint Dominic**
Niccolò da Bologna
Leaf from a register of the
Shoemakers' Guild
Bologna, ca. 1386
JPGM, Ms. 82, recto

This page comes from a list of members of
the shoemaker's guild, specifically, those who
lived in Bologna's San Procolo neighbor-
hood. The miniature depicts Saint Dominic,
the patron saint of the local church. The
guild's arms appear in the lower margin.
Unlike the celestial fleurs-de-lis or mighty
lions that figure in aristocratic heraldry, the
guild's arms are literally down to earth: their
shield bears a shoe, a sandal, and a leather-
cutting tool.

58 ▷
**Charles the Bold Receives His
Military Captains**
Master of Fitzwilliam 268
Military Ordinance of Charles the Bold
Bruges, 1475
BL, Add. Ms. 36619, fol. 5

Charles the Bold, duke of Burgundy, issued
this military ordinance in 1475. He sits
enthroned in the center of the room sur-
rounded by his counselors, who wear around
their necks the insignia of the Order of the
Golden Fleece, which Charles founded.
Although made for Charles, the portrait
is generic, with the duke identified by his
heraldry, the conjoined *C* and *M* on the back
wall (the initials of Charles and his wife,
Margaret of York), and his mottoes written
on the ceiling beams, "Je lay emprins"
(I have undertaken it) and "Bien en aviengne."
(May good come of it).

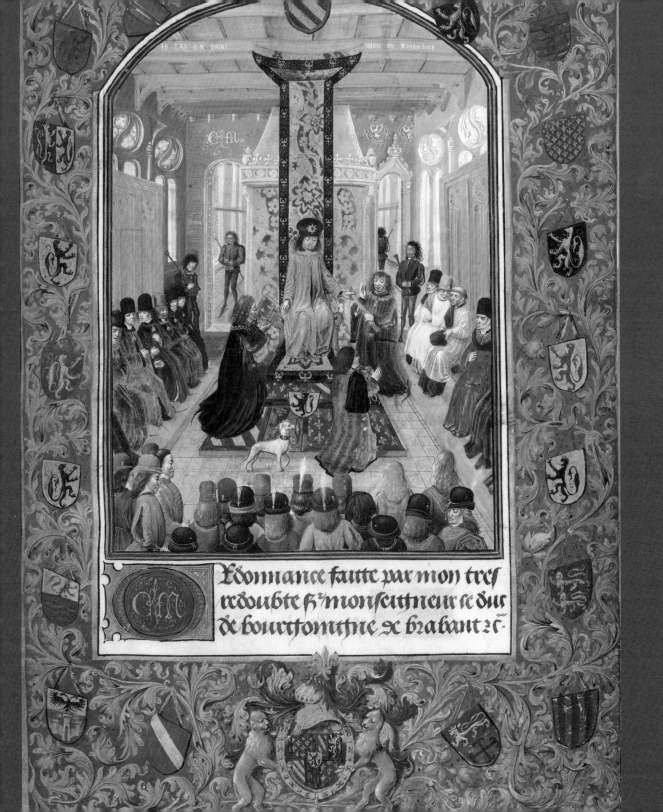

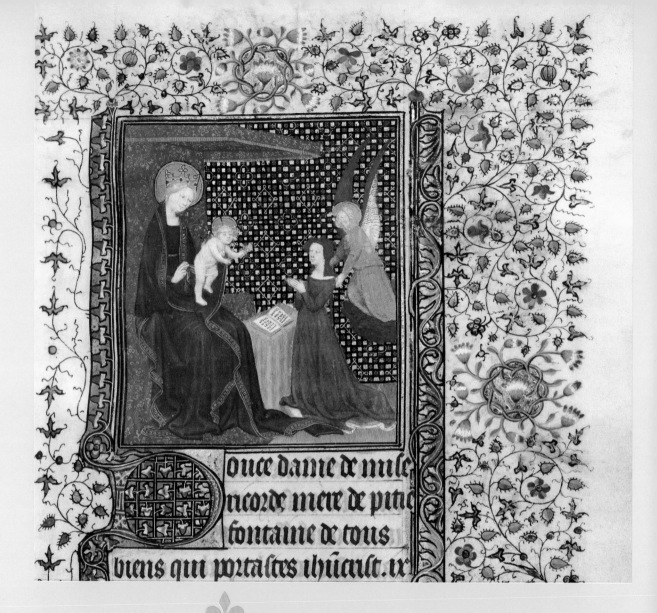

**59** △
**A Patron Presented to the Virgin and Child**
Workshop of the Boucicaut Master
Book of hours
Paris, ca. 1415–20
JPGM, Ms. 22, fol. 137

## OWNERS

Books are important belongings, and owners are always eager to mark books as their possessions. Portraiture is a particularly impressive way of marking this ownership, and it was used throughout the Middle Ages and Renaissance. Prior to 1300, royal and ecclesiastical patrons were almost alone in commissioning these sorts of images; after this date, books become more widespread in society, and owner portraits do as well (fig. 59). Their tasks also went well beyond claiming possession. In religious manuscripts, portraits were inserted into the most important pictures to stimulate the viewer's devotional attention.

**Initial *S*: The Virgin and Child
(with a Knight in the Border)**
Ruskin Hours
Northern France, ca. 1300
JPGM, Ms. Ludwig IX 3, fol. 52v

This book's owner kneels at the bottom
of the page; hands clasped, he prays
to the Virgin and Child in the initial
above. Although the artist made no at-
tempt to individualize the owner's face,
the portrait communicates important
messages about its subject's status and
piety; this man wears a knight's armor,
thus proclaiming his prestigious rank.
Conversely, his placement beneath the
last line of text underlines his humble
approach to the Virgin and Child above.

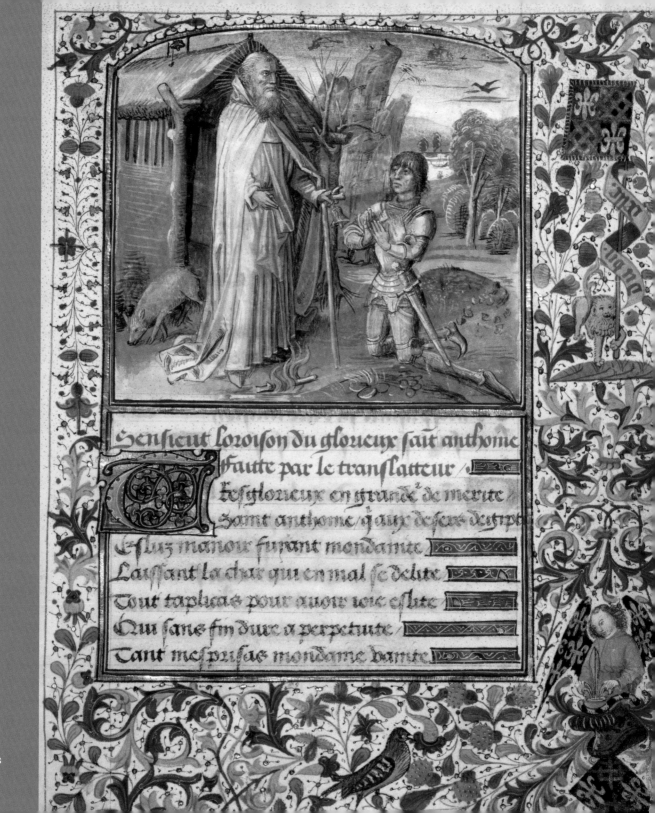

Sensieut loroison du glorieux sait anthome
faute par le translatteur

est glorieux en grande de merite
Sainct anthome q aux dese ss descript
Esluz manoir fuyant mondainte
Laissant la char qui en mal se delite
Tout tapplicas pour auoir roie esluite
Qui sans fin dure a perpetuite
Tant mespriscas mondaine vanite

**61** ◁

**A Knight before Saint Anthony**
Dreux Jean or Workshop
*Discovery and Translation of the Body
of Saint Anthony*
Probably Brussels or Bruges, ca. 1465–70
JPGM, Ms. Ludwig XI 8, fol. 50

This portrait of the book's unidentified
owner praying before Saint Anthony exempli-
fies the way fifteenth-century portraits blend
medieval traditions with a novel realism. The
artist observed the traditional rules by depict-
ing the owner in a calm pose with a somber
expression on his face. However, the artist
breaks from earlier medieval conventions by
realistically depicting the owner's features:
the longish hair, meaty cheeks, prominent
nose, and heavy-lidded eyes create a recogniz-
able individual likeness. Anthony's face bears
the same realistic stamp we see on his fol-
lower: the taste for realistic portraiture of the
living affected the appearance of imaginary
portraits of the dead.

**62** ▷

**Patron and Guardian Angel**
Fastolf Master
Book of hours
Probably Rouen or England?, ca. 1430–40
JPGM, Ms. 5, fol. 20v

Although realistic likenesses had been in
use for close to a century when this book
was painted, the portrait it includes seems
generic and conventional. The generic por-
trait, however, tailors a standard book to its
specific audience without requiring the
expense or labor involved in customizing
it, just as certain prayers are given either a
masculine or feminine cast in contemporary
books of hours. But if the portrait lacks a
distinctive likeness, the individual still
matters here, as he is accompanied by his
very own guardian angel. The belief that
each person had a particular angel assigned
to protect him or her is a dramatic recog-
nition of individuality.

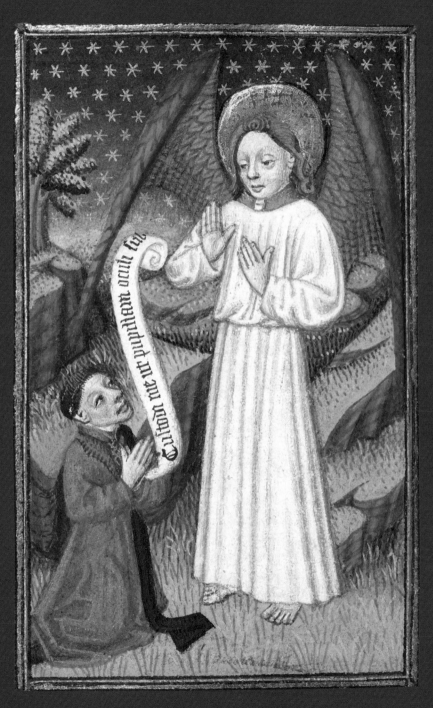

**Saint Bellinus Celebrating Mass
before Andrea Gualengo and His Family**
Taddeo Crivelli
Gualenghi d'Este Hours
Ferrara, ca. 1469
JPGM, Ms. Ludwig IX 13, fol. 199v

This image accompanies a prayer to
Saint Bellinus, a twelfth-century bishop
of Padua. Kneeling before him are
four members of the Gualenghi-d'Este
family. The well-fed Andrea Gualengo
places his hands in the saint's in a ges-
ture of loyalty, while Gualengo's wife,
Orsina d'Este, and two sons look on.
As portraiture became more realistic,
patrons also demanded a plausible
setting; as always, the donors adopt a
respectful pose before the saint, but
unlike in earlier medieval images, they
occupy the same space and are the same
size as Bellinus. Andrea's whole family
is dressed in their Sunday best, so that
the image presents both their religious
devotion and their very earthly riches.

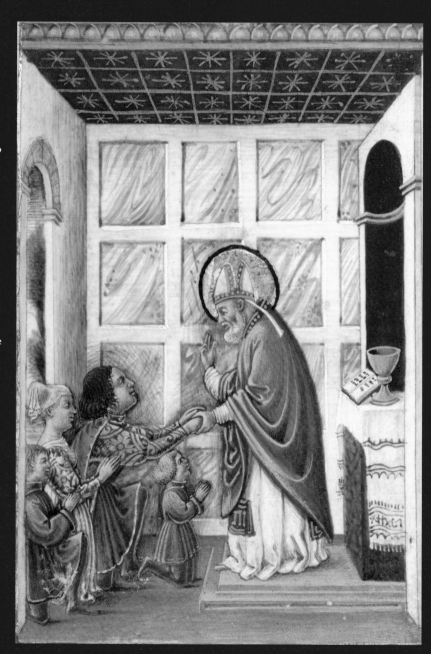

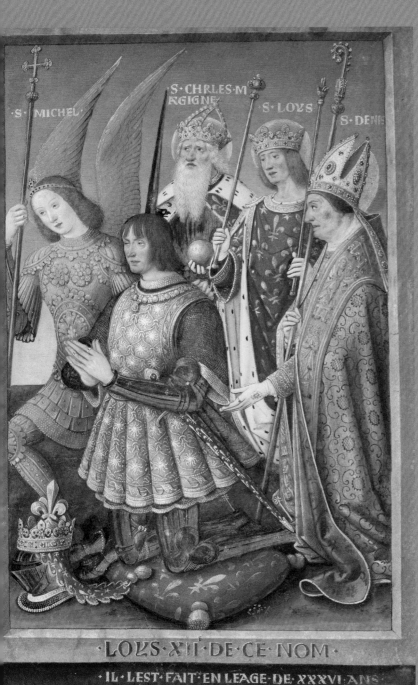

S·MICHEL · S·CHRLES·M RGIGNE · S·LOYS · S·DENIS

LOVS·XII·DE·CE·NOM·

IL·LEST·FAIT·EN·LEAGE·DE·XXXVI·ANS·

**Louis XII of France Accompanied by Saints Michael, Charlemagne, Louis, and Denis**
Jean Bourdichon
Leaf from the Hours of Louis XII
Tours, 1498–99
JPGM, Ms. 79a, recto

Jean Bourdichon was the official royal artist for four French kings, and his responsibilities included painting his ruler's portrait even when, as in Louis's case, the royal likeness was nothing to celebrate. This image comes from Louis XII's book of hours; in the original manuscript, Louis prayed toward the facing page, which probably depicted the Virgin and Child. Louis's features are recognizable from a host of portraits made during his lifetime. He is also identified by the fleurs-de-lis, the heraldry of France's kings. As king of France, Louis led the chivalric Order of Saint Michel, and he wears the order's collar around his neck, while the order's patron saint, the archangel Michael, kneels to his right. Behind him stand three saints closely linked with the French monarchy: Emperor Charlemagne, King Louis IX, and Denis, the first bishop of Paris. Significantly, of the four, the king's name saint, Louis IX, most closely resembles the living king.

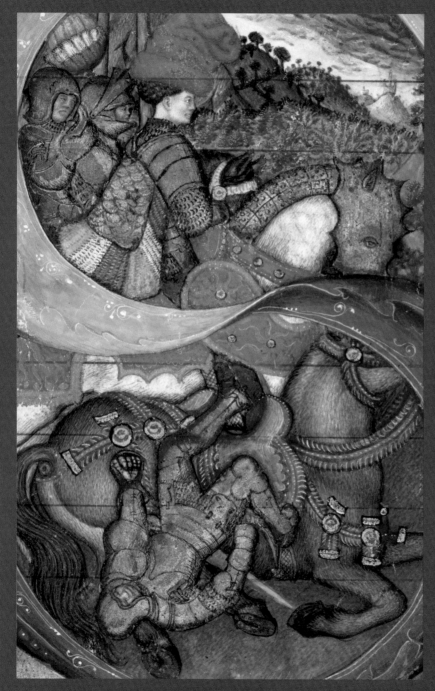

**65** ◁

**Initial *S*: The Conversion of Saint Paul**
Attributed to Pisanello and the Master of
Antiphonal Q of San Giorgio Maggiore
Cutting from a gradual
Probably northern Italy, ca. 1440–50
JPGM, Ms. 41, verso

Pisanello worked for the Gonzaga court,
where he was particularly well known for
his portraits. Here he depicts Ludovico
Gonzaga in profile, a format more com-
mon in Italy than the three-quarter profile
preferred in northern Europe. The radiant
sun on the horse's trappings is Ludovico's
personal device, while his mantle bears
the red, green, and white colors of the
Gonzaga family. Ludovico's portraits often
feature impressive headgear, but none can
equal the extraordinary red specimen he
sports here.

Recalling classical art, this equestrian
image emphasizes Ludovico's proud and
steady control of his horse (not to mention
that incredible hat). His poise contrasts
with the tumbling horseman below. This is
none other than Saint Paul, who fell from
his horse while dazzled by a revelatory
vision on the road to Damascus, prompt-
ing his conversion to Christianity. The
miniature, cut from a choir book commis-
sioned by the Gonzaga, once decorated a
chant celebrating Paul's conversion. Given
this context, it is striking that Pisanello
focuses on his patron, not the saint.

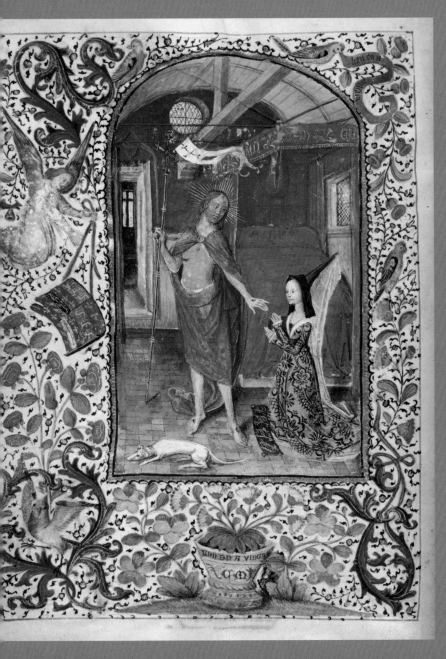

**Margaret of York and the Risen Christ**
Follower of Dreux Jean
Nicholas Finet, *Dialogue of the Duchess
of Burgundy with Jesus Christ*
Brussels, after 1468
BL, Add. Ms. 7970, fol. 1v

Margaret of York, duchess of Burgundy,
kneels before Christ in a bedchamber.
Christ's staff, long red robe, and pierced
side mark him as the Resurrected
Christ, while his gesture and Marga-
ret's placement are based on images of
Christ's appearance to Mary Magdalene
after his resurrection. Thus, this image
uses composition and portraiture to
compare Margaret to the Magdalene,
one of Christ's most important female
followers.

**67** ◁

**The Crucifixion with a Kneeling Woman**
Follower of the Master of James IV of Scotland
Book of hours
Cologne and probably Ghent, ca. 1500
JPGM, Ms. Ludwig IX 17, fol. 86v

This Crucifixion pairs the Virgin Mary
and Saint John with the book's owner and
a smaller female, probably her daughter, at
the left. Though the image as a whole fea-
tures the realism we expect of late medieval
and Renaissance art, these portraits are not
individualized: the book's owner has the
same facial features as the Virgin Mary.
The artist identifies the subject by provid-
ing her with rich contemporary clothing
and by placing her coat of arms in the mar-
gin. These proud tokens of family wealth
may seem out of place in this devotional
context; for Protestant reformers such as
Martin Luther they were a sign of indi-
vidual vanity that undercut any potential
usefulness the image might have.

**68** ▷

**The Visitation**
Gerard Horenbout
Sforza Hours
Milan, ca. 1490; with Flemish additions,
ca. 1517–20
BL, Add. Ms. 34294, fol. 61

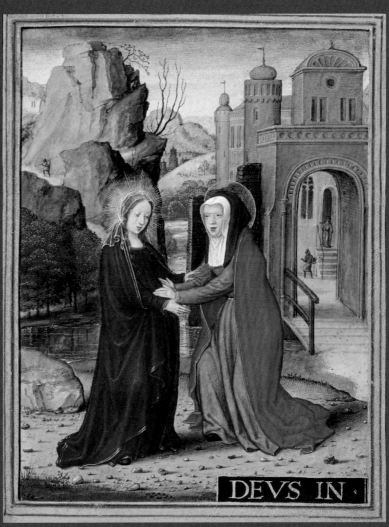

Begun for Bona Sforza, the Sforza Hours
passed unfinished to Margaret of Austria,
regent of the Netherlands, who commis-
sioned Gerard Horenbout to complete it.
Horenbout's work includes a depiction of
the Visitation, when Mary, pregnant with
Jesus, visits her relative Elizabeth, who is
pregnant with John the Baptist. Rather than
showing Margaret as a devout bystander
witnessing this event, as was customary in
devotional portraiture, Horenbout went a
step further, assigning Margaret's features
to Elizabeth. Thus, she actually becomes a
sacred participant in history as one of the
first to recognize Christ's incarnation.
Portraits like this, called historiated por-
traits, were impossible before por-
traiture assumed its new link with the
world of appearances. Such portraits
could aggrandize their subjects, and
Horenbout dodges that risk by making
the aged Margaret look dowdy next to
the glamorous Mary.

## AN OWNER IN FOCUS:
### SIMON DE VARIE

Simon de Varie was a minor official at the French court who commissioned this book of hours in the mid-fifteenth century. A complex production, the book was illustrated by three artists, including Jean Fouquet, the most celebrated illuminator of his time. The commission was personally important to Simon, and his portraits, heraldry, and motto appear repeatedly in the book, allowing us to see the multiple ways a single person's identity could be expressed.

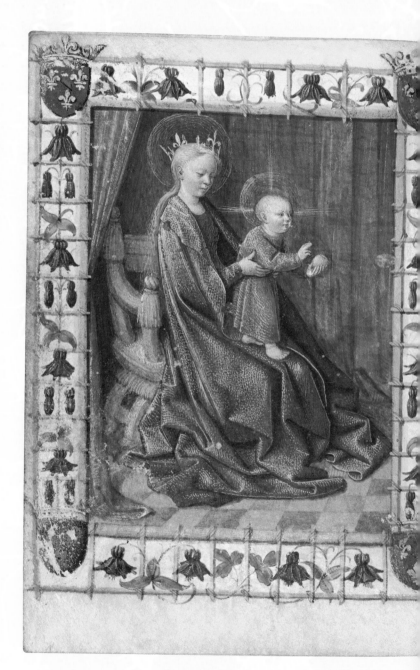

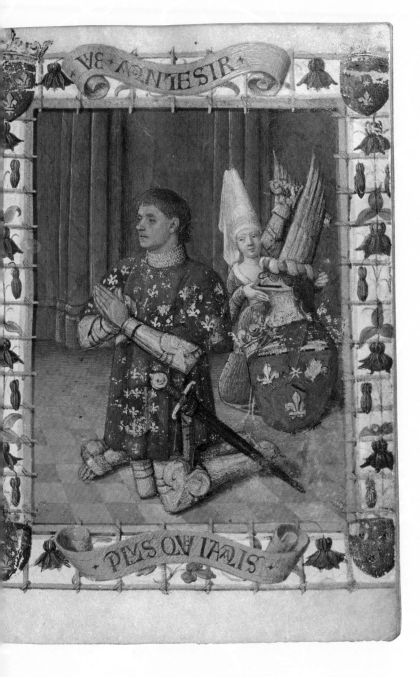

**Simon de Varie Adoring the Virgin
and Child**
Jean Fouquet
Hours of Simon de Varie
Tours, 1455
JPGM, Ms. 7, fols. 1v–2

Simon de Varie kneels in prayer before
the Virgin and Child, accompanied by a
woman who holds a shield that once bore
his arms (it was later overpainted with
fleurs-de-lis). The opening also bears his
personal motto, "Vie a mon desir" (Life
according to my desire), a skillful ana-
gram, or rearrangement of the letters, of
his name. Above all, though, Simon's iden-
tity is conveyed by his portrait. Fouquet's
delicate brushwork created a nuanced
depiction of Simon's face, the result of the
artist's close study of his subject.

Fouquet was acclaimed as a portraitist
in his lifetime; Francesco Florio, an Italian
humanist living in France, wrote that the
artist's "penetrating vision . . . enabled
him to render a perfect likeness," while
Filarete, a Florentine architect and sculp-
tor of the Italian Renaissance, praised him
as "a good master, especially for doing
portraits from life." Given Fouquet's skill
as a portraitist, it is not surprising that in
this collaborative book project, Fouquet's
most important contribution is Simon's
portrait.

**The Virgin and Child Adored by
Simon de Varie**
Master of Jean Rolin II
Hours of Simon de Varie
Tours, 1455
The Hague, Koninklijke Bibliotheek,
Ms. 74 G 37, fol. 1

The novel force of Fouquet's portrait is
all the more apparent when compared to
the more traditional and less imposing
image of Simon painted by a different
artist in the same book. It is striking
that these two images, which exemplify
two very different approaches to por-
traiture, appear in the same book. While
they are distinguished by their styles,
they are alike in their iconography: both
show Simon dressed as a knight. This
is likely something of an affectation:
as a minor bureaucrat in the French
treasury, Simon is unlikely to have had
much cause to wear armor.

**71**
**David in Penitence
(with Owner's Marks in the Border)**
Chief Associate of the Bedford Master
Hours of Simon de Varie
Tours, 1455
JPGM, Ms. 7, fol. 45

The recently ennobled Simon de Varie
was proud of his newly created family
arms, which appear in the margin of
this page, held by a young woman in an
enclosed garden. One of Varie's mottoes,
"Plus que jamais" (More than ever),
decorates the scroll at the top; the *T* and
*R* joined by a love knot are also associ-
ated with Simon, but their significance
remains unknown.

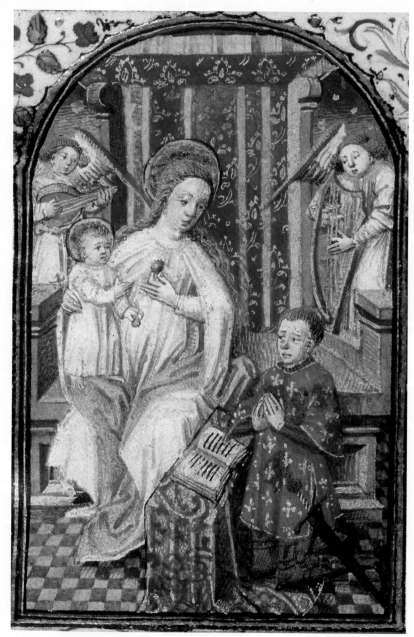

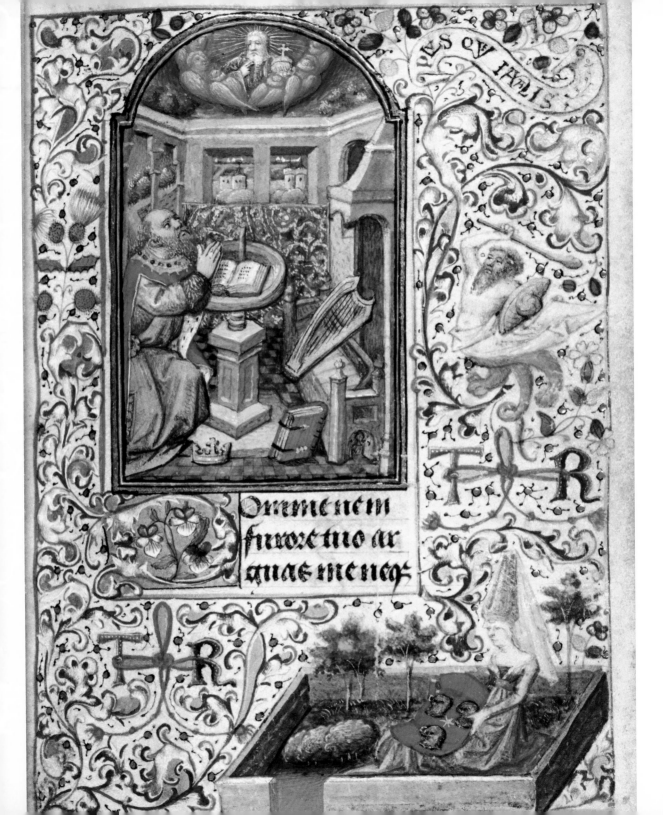

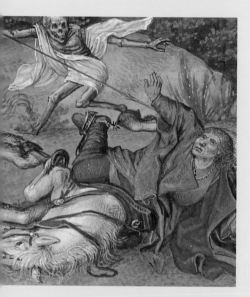

Detail of fig. 74 (page 82)

## EPILOGUE: PORTRAITURE, MEMORY, AND PRIDE

Portraiture and memory travel together; we prize antique photographs of our ancestors, which help us remember them, and we send pictures of ourselves to distant friends so that they will remember us. Many of the portraits discussed in this book were created to preserve a person's memory after death. In the Stammheim Missal, for example, Geverhardus and Widikindus hoped that their labeled portraits would allow the book's later users to remember their contribution to the monastery and reward it with their prayers (fig. 8). Christine de Pisan included her portrait in the book she gave Isabelle so that the queen might remember—and reward—her generosity (fig. 53). And while Louis XII's image was painted to inspire his devotions, the artist also anticipated that later viewers would look to the portrait for an accurate historical record of the king's appearance; thus he indicated in the lowest label that the image shows the king at the age of 36 (fig. 64).

The link between portraiture and memory was clearest in tomb sculptures. For those able to afford one, the most desirable tomb showed the deceased life-sized, recumbent on the sepulchre, as we see in the Spinola Hours' Office of the Dead (fig. 74). The Office of the Dead was a required text in books of hours, furnishing prayers for the dead and reminding readers of their own mortality. The Spinola image presents four stages of death and burial. Below, a man on horseback takes a fatal fall and is eagerly set upon by skeletons, while directly above he lies on his deathbed; on the opposite page we see, at the top, his funeral service in the choir of a church, and below, his tomb in the crypt, complete with his portrait sculpted on the lid and heraldic emblems decorating the sides. Such tombs became increasingly popular in the same centuries that saw the rise of the individualized portrait. Gathering at the tomb, mourners would pray for the deceased's salvation, with the tomb's portrait memorializing his or her identity.

While these grand tombs were popular, particularly with aristocrats, they were not without their critics. In his *Book of Good Morals*, Jacques Legrand cautioned that elaborate tombs "signify pride and vanity. And if you tell me that you do it only so that people will pray for you when they see the portrait, to this I respond that I have hardly noticed that people were moved to devotion or prayer by [tombs], though I have seen many people gape and plot and chatter because of sepulchres." In a miniature accompanying Giovanni Boccaccio's account of the deaths of Marc Antony and Cleopatra, the famous lovers from antiquity, an artist showed the couple celebrated with a medieval-style tomb (fig. 72). The two men pointing and talking nearby may be just the kind of gossipy visitors Legrand found repellant.

The condemnation of tomb portraits as emblems of pride and vanity is a late medieval development. The individualized, accurate portraits developed in this period recalled nothing so much as Narcissus, who fell in love with his reflection in a pool where, fascinated by his likeness, he lingered until death; hence the word "narcissistic" (fig. 73). Moralists criticized the vain preoccupation with personal appearance and lasting fame, which had in part been nurtured by the new portraiture. Artists in turn also created images to

ont les visaiges moult changies et divers

e .rvᵉ. et deuant chapitre conu

remind viewers that their fleeting beauty was less important than their eternal salvation. The "mirror of conscience," which reflected not the viewer's face but a skull, was one such image. Finding a skeleton in the mirror reminded the book's owner, in this case Joanna of Castile, that her worldly appearance would ultimately crumble to dust (fig. 75). Similarly, in the Hours of René of Anjou, a grinning skeleton wears a royal crown and stands behind a banner bearing King René's coat of arms (fig. 76). In looking at this image, René was confronting a prophetic portrait of his own corpse.

It is well to note, however, that even as the artists included these moralizing images in the pages of their books, the attachment to portraits remained undiminished. Joanna's book features two portraits of her, and King René also commissioned many portraits of himself, his wife, and his courtiers. Viewers were prepared to acknowledge the risks of portraiture. But in the end portraiture's satisfactions—both secular and religious—made those risks worth taking.

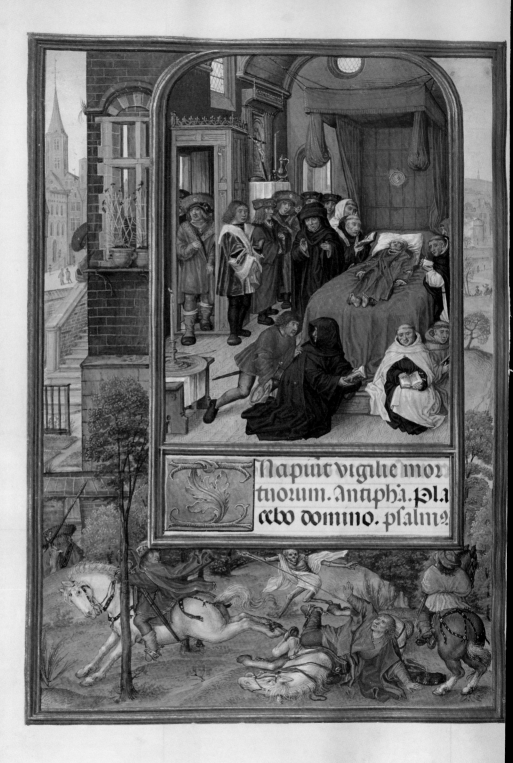

Ucn quoniam exaudi
et dominus nocem o
rationis mee.

75 ◁
**The Mirror of Conscience**
Master of the David Scenes in
the Grimani Breviary
Hours of Joanna of Castile
Bruges or Ghent, between 1496
and 1506
BL, Add. Ms. 18852, fol. 15

76 ▷
**The Figure of Death Wearing
the King's Crown**
Master of René of Anjou?
Hours of René of Anjou
Paris, ca. 1422/43
BL, Egerton Ms. 1070, fol. 53

Siquitur Officia Mortuor

Jonathan Alexander, *Medieval Illuminators and Their Methods of Work* (New Haven and London, 1992).

Richard Brilliant, *Portraiture* (Cambridge, Mass., 1991).

Caroline Walker Bynum, "Did the Twelfth Century Discover the Individual?" in Bynum, *Jesus as Mother: Studies in the Spirituality of the High Middle Ages* (Berkeley and Los Angeles, 1982), pp. 82–109.

Lorne Campbell, *Renaissance Portraits: European Portrait-Painting in the Fourteenth, Fifteenth and Sixteenth Centuries* (New Haven and London, 1990).

Ernst Gombrich, *Art and Illusion: A Study in the Psychology of Pictorial Representation*, 6th ed. (New York, 2002).

Ernst Kitzinger, *Byzantine Art in the Making* (Cambridge, Mass., 1995).

Charles T. Little, ed., *Set in Stone: The Face in Medieval Sculpture*, exh. cat. (New York, The Metropolitan Museum of Art, 2006).

James Marrow, *Pictorial Invention in Netherlandish Manuscript Illumination of the Late Middle Ages: The Play of Illusion and Meaning* (Louvain, 2005).

Stephen Perkinson, "Portraits and Counterfeits: Villard de Honnecourt and Thirteenth-Century Theories of Representation," *Excavating the Medieval Image: Manuscripts, Artists, Audiences—Essays in Honor of Sandra Hindman*, ed. Nina A. Rowe and David Areford (Aldershot, United Kingdom, 2004), pp. 13–35.

Carol J. Purtle, ed., *Rogier van der Weyden, "Saint Luke Drawing the Virgin": Selected Essays in Context* (Brussels, 1997).

Georgia Sommers Wright, "The Reinvention of the Portrait Likeness in the Fourteenth Century," *Gesta* 39/2 (2000), pp. 117–34.

## BOOKS OF RELATED INTEREST FROM GETTY PUBLICATIONS AND BRITISH LIBRARY PUBLICATIONS

*Beasts Factual and Fantastic*
Elizabeth Morrison
112 pages
111 color illustrations
(J. Paul Getty Museum / British Library)

*Flemish Illuminated Manuscripts,*
*1400–1550*
Scot McKendrick
160 pages
140 color illustrations
(British Library)

*French Illuminated Manuscripts in*
*the J. Paul Getty Museum*
Thomas Kren
144 pages
120 color illustrations
(J. Paul Getty Museum / British Library)

*Illumination from Books of Hours*
Janet Backhouse
160 pages
140 color illustrations
(British Library)

*Italian Illuminated Manuscripts in*
*the J. Paul Getty Museum*
Thomas Kren and Kurt Barstow
96 pages
80 color illustrations
(J. Paul Getty Museum)

*A Masterpiece Reconstructed:*
*The Hours of Louis XII*
Edited by Thomas Kren with Mark Evans
112 pages
77 color and 10 b/w illustrations
(J. Paul Getty Museum / British Library)

*A Treasury of Hours:*
*Selections from Illuminated Prayer Books*
Fanny Faÿ-Sallois
128 pages
55 color illustrations
(J. Paul Getty Museum)

*Understanding Illuminated Manuscripts:*
*A Guide to Technical Terms*
Michelle P. Brown
128 pages
64 color and 33 b/w illustrations
(J. Paul Getty Museum / British Library)

## THE MEDIEVAL IMAGINATION SERIES

The Medieval Imagination series focuses on particular themes or subjects as represented in manuscript illuminations from the Middle Ages and the early Renaissance. Drawing upon the collections of the J. Paul Getty Museum and the British Library, the series provides an accessible and delightful introduction to the imagination of the medieval world. Future volumes will cover marginal imagery and music, among other topics.

## ABOUT THE AUTHOR

Erik Inglis teaches medieval art history at Oberlin College. He was introduced to the study of medieval manuscripts in graduate school and as a graduate intern working in the Department of Manuscripts at the J. Paul Getty Museum. His publications center on court art in later medieval France, from art and ritual at the court to the work of the court painter Jean Fouquet. He is also interested in the historiography of medieval art and has published articles on Jean de Jandun's architectural criticism and the art historian Meyer Schapiro.

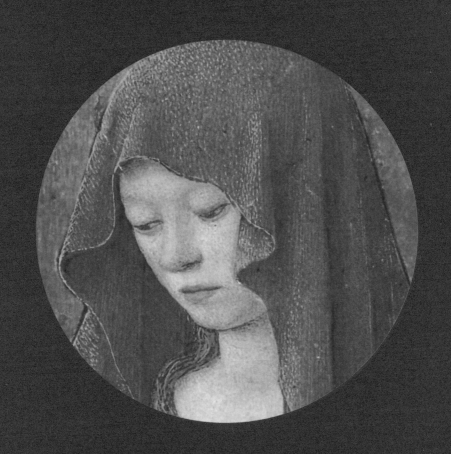